DRAW MANGA
COMPLETE TECHNIQUES
The Ultimate Step-by-Step Guide To Creating Your Own Manga World

ELVIN AND FELDER

k

kandour Ltd

Published by
Kandour Ltd
1-3 Colebrooke Place
London N1 8HZ
United Kingdom

This edition printed in 2006 for
Chartwell Books, Inc.
A division of
Book Sales Inc.
114 Northfield Avenue
Edison
New Jersey
08837

First published 2005

Written and illustrated by Emmett Elvin and Eugene Felder
Cover and content design: Eugene Felder and Emmett Elvin

© Kandour Ltd 2005

ISBN-10: 0-7858-2126-0

ISBN-13: 978-0-7858-2126-7

Printed in India

CONTENTS

FOREWORD

Unlike the majority of Manga books on the market – where the reader is required to do little more than copy the artwork on the pages – we hope this book helps you develop your own style and gives you a greater understanding of this fascinating art form.

By gaining an appreciation of important aspects such as line, form and structure, you will be equipped to create your very own Manga art with confidence and originality.

All the fundamentals are here. As for how deeply you wish to investigate the subject – it's over to you!

Enjoy!

Emmett Elvin and Eugene Felder

In a relatively short period of time Manga's popularity has exploded in the Western world. Our introduction to this art form came not through comics, but from television series or animes.

The initial titles that came to our shores were not stand-alone creations but rather a means of marketing products to children: the Transformers, Gundam, Beyblade, Pokemon and other kids' characters. The success of these has spurred on the productions of other titles. But not all of these started life as a way of marketing plastic toys.

It is important to remember that not all Manga and anime is created purely for this end. One of the reasons that Manga is still fresh and exciting is because the people who create it do so out of love of the art form. For them, it is not simply a commercial endeavor, but the fulfillment of a creative desire.

To become a great Manga-ka – or master of the art form – requires devotion beyond any potential financial reward. If you're reading this book you've probably been inspired by the work of a Manga artist and would like to develop your own skill to a similar level.

This is the single most important factor you will need to gain inspiration – the simple desire to create work as good as that of the people we admire. It may take you a while to get there, but along the way breakthroughs in understanding will occur.

There are few things more satisfying than the sudden realization of why something works and exactly how to do it. When these breakthroughs come, we have them not just for that moment, but for the rest of our artistic lives. Our understanding grows and undertakings, which once seemed almost impossible become second nature to us.

This book aims to be an illustrative guide to drawing Manga, with the emphasis on illustrative. The most important things you will need, apart from imagination, are a pencil and paper. An eraser and sharpener will also be indispensable. For finishing your drawings we recommend black Indian ink and either a brush or dip pen. Some artists like to use marker pens or even ballpoints. The disadvantage of these instruments is a less expressive line.

Pencils range from 9H (very hard) through F and HB to 9B (very soft). Soft pencils are great for sketching.

Their biggest advantage is the range of tones and the ease with which they can be erased, but can be problematic for the same reason; i.e. the tendency to smudge. Hard pencils produce a constant and light line and, if pushed, have a tendency to score the paper. They are very useful for technical graphic artists, who need almost invisible guides, which are later drawn over and /or removed in reproduction. We have found that for drawings that will be later inked, pencils between 3H and HB are best. We all develop personal preferences, so it's always best to experiment until you are comfortable.

For fixing drawings to stop smudging, super hold hairspray is a good alternative to expensive fixative. It also smells better!

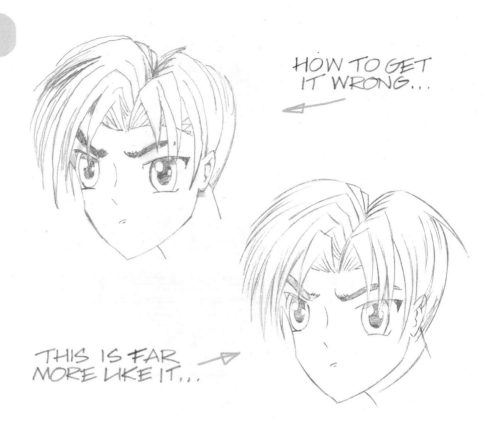

HOW TO GET
IT WRONG...

THIS IS FAR
MORE LIKE IT...

Above are two versions of the same illustration. The one on the left is the result of drawing with a weak, less-than-confident line. Pencil strokes have been made with both a blunt and sharp tip, causing wide variations in line width. This contributes to a lack of consistency.

We should always try to communicate visual ideas with the minimum of complication. The reader must be able to "read" the image as quickly as possible. To achieve this we have to make sure all pencil lines make visual sense.

The version on the right is how it should be done. The image is executed with fast, confident strokes, resulting in an image that really hangs together. The reader therefore has no difficulty seeing exactly what is being communicated.

Besides the obvious point of keeping our pencils sharp, the key factor is confidence. This only comes with time and a great deal of practice. It's about knowing almost instinctively what the exact result of any one pencil stroke will be. This means "seeing" the image on the paper before it has been drawn.

If all this sounds a little abstract right now, don't worry. Just keep practicing and all will become crystal clear.

If you have a drawing that is good but that has become irredeemably overworked then trace it, don't waste it!

How you hold the pencil has a great impact on the quality of the line drawn. The closer to the tip it is gripped, the smaller the range within which you can draw a smooth line without having to move your entire arm. The further to the butt, the less control you have over the instrument. For comic illustration the optimum is about halfway along, with the shaft resting in the crux between the thumb and forefinger. Every artist will find what best suits his or her style. Again this preference can only be arrived at through experimentation and lots of drawing. The same guidelines apply when using any pen-like medium, including a brush.

Most Manga is inked, and because of this the paper used is very smooth and bleed-proof. This means that the ink flows easily over the page and each line maintains a nice crisp edge. A heavier paper like Bristol board allows a lot of liquid to be applied without warping the paper. A layout pad, with its ultra thin sheets, although not as durable, has the advantage of being easy to trace through. Another factor in getting a strong black line is the thickness of the ink. Thin ink is very fluid and often gray rather than black on white paper. Thicker ink is harder to flow. This makes creating a beautiful line a balance between material and technique.

Always wash your hands before drawing. This removes any residue and will allow your hand to glide over the paper.

HOW TO GET IT WRONG...

THIS IS FAR MORE LIKE IT...

Above left: Overfussiness, a lack of confidence and an inconsistent line all contribute to a confusing and unsightly ink job.

Above right: The job has been done correctly. Consistency and confidence produce a professional finish.

Nothing tends to strike fear into the heart of many beginners more than the art of inking. The thought of ruining some great pencils with poor inks has a habit of seriously undermining confidence. Just as with pencils, it's really a question of practice. The more inking you do, the better idea you have of the outcome of any particular approach.

The key point when inking is integration. This means making all the component parts of the scene relate to each other in such a way that the whole image makes visual sense. Line strength of scenery in the far distance will always be much weaker than

that of the extreme foreground. This is where you are able to make an apparent inconsistency work for you. By breaking any scene down to foreground, midground and background, you can use line strength to create real depth of image. The above images illustrate this important principle.

The other highly important thing to mention is focus. Where do you want the reader's attention to be? On an unimportant part of the background? No! Use the inks to emphasize the important and play down any part of the image which functions as little more than decoration.

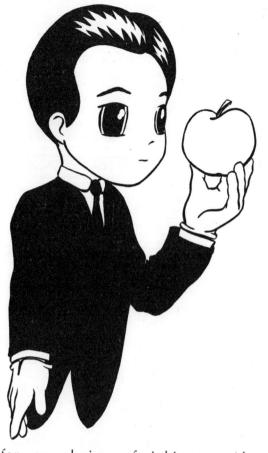

As far as choice of inking equipment is concerned, this is purely a personal matter. Some prefer a dip pen, others a brush. For the record, the vast majority of inked images in this book were done with a brush. It's a very good idea though to be adept in both mediums. Some jobs are simply better done with a pen. We tend to use pens for architecture and other technical stuff and a brush for more organic forms such as the human figure. The final choice is yours. Again, experiment and find what you are comfortable with. Both pens and brushes come in a huge variety of styles and sizes. Try a few out and see what works for you.

Always wait as long as is practicable before cleaning up left-over pencil on your inked images. Even though the ink may seem dry in just a few minutes, the hardening component in the ink, usually shellac, can take a lot longer to harden properly. Early erasing will remove the top layer of ink, leaving you with gray rather than solid black lines.

If there is a key word in this book – and Manga in general – it has to be practice. Every hour spent drawing when you don't really feel like it is worth five when you do. Inspiration is one thing, but nothing beats dedication.

Wait for each ink line to dry before working anywhere near it. This will avoid the danger of smudged ink.

The single most important element in Manga is the figure. If we can master this, everything else should fall into place. There's a basic "true form" from which all these figures are based... ourselves.

Understanding the human form provides a basis from which we can begin our own creations, be they samurai bunnies or cyborg grandparents. Artists deliberately mutate the human form in order to suit their own ideas. The directions are infinite. These two pages show a small sampling of those possibilities, yet all can be described as humanoid.

Often, Manga titles have a limited backdrop for the heroes – speed lines, flat color/tone or patterns. The story is told with little more than just the characters.

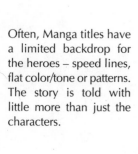

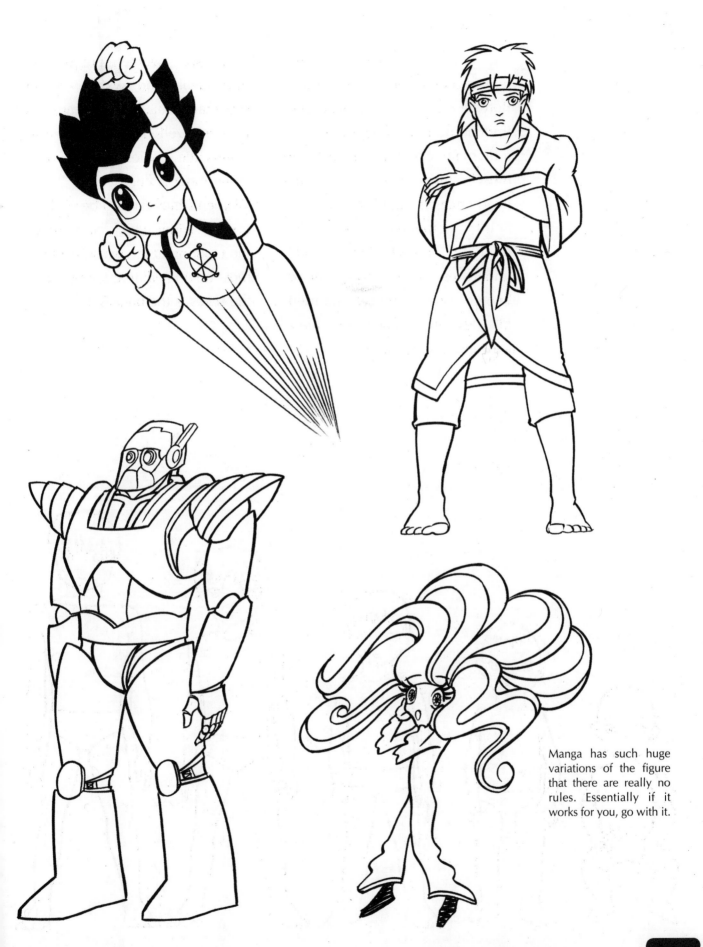

Manga has such huge variations of the figure that there are really no rules. Essentially if it works for you, go with it.

Up until puberty, male and female bodies look very alike. Between the ages of eleven and thirteen hormones begin to have a dramatic effect, particularly on muscle mass. The size of the head changes little from child to adult compared with the dramatic growth the body undergoes. Men tend to grow bigger with more defined muscles, and broader shoulders tapering toward the waist.

Conversely, women are usually more petite and, with a natural subcutaneous fat layer, muscles are less well defined. This also means the bodies have a more streamlined, curvaceous look. Women's hips tend to be proportionally wider which emphasizes the tapering at the waist. And the most obvious difference between the sexes is the breasts.

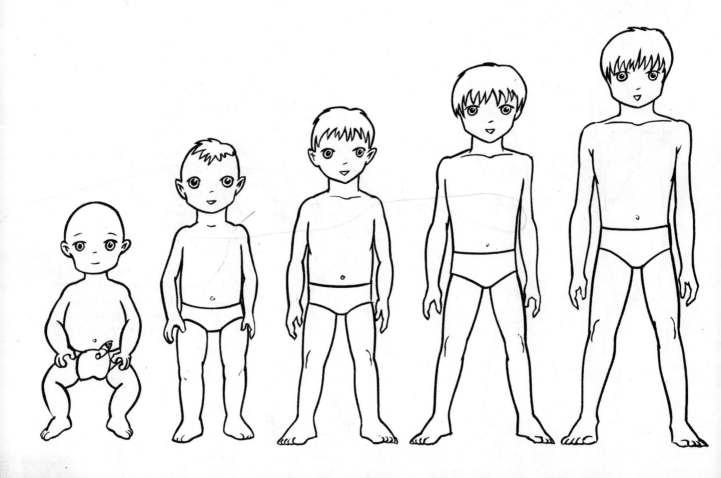

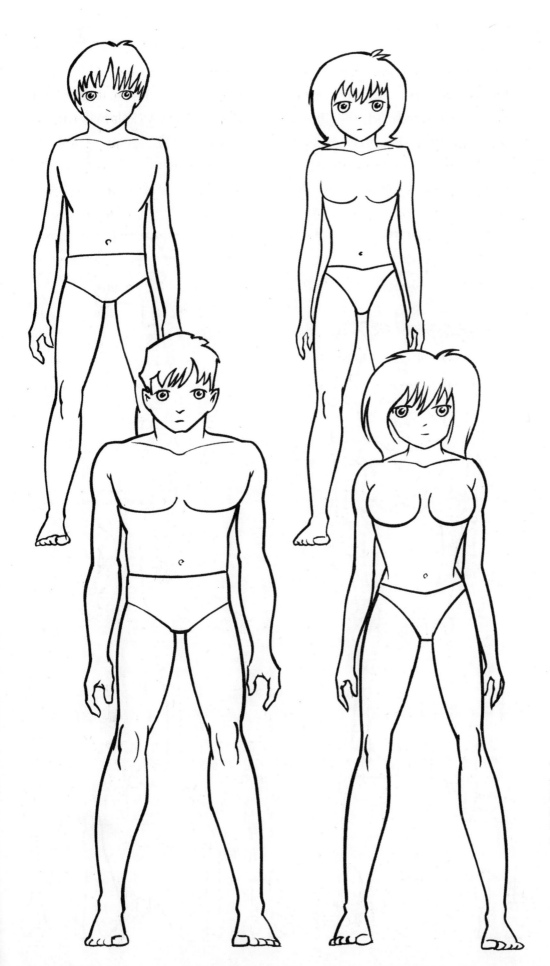

These two pages explore the general trends of body shape from birth to adulthood. This should inform our drawing, not restrict it.

The majority of mammals have essentially the same bone structure as humans: body, limbs and head. Obviously proportions and detail vary, even within species. In humans the female skeleton tends to be smaller with wider hips and slightly in-bent knees. The male skeleton tends to be taller and broader, notably at the shoulders.

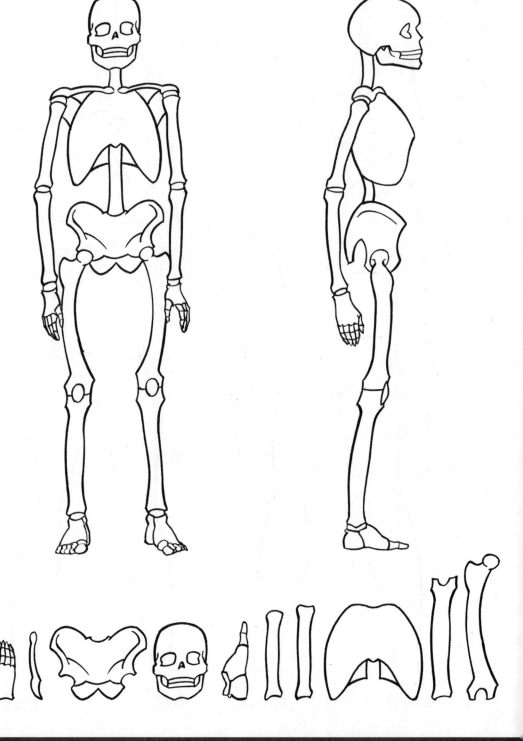

The ratio between bone sizes remains relatively consistent. We can calculate a person's height quite accurately just by measuring the length of their thigh bone.

Understanding the underlying structure of the body is crucial to good figure drawing. The skeleton is the most fundamental part of this. It tells us where the joints are and how they bend. The ratio between bone sizes helps us to maintain consistent proportions. It also serves as the frame onto which we attach the muscles.

The old masters used to cut up dead bodies in order to gain better understanding. Thankfully we now have anatomy books. On these pages we are providing only the basis needed to draw Manga. As we develop as artists, so should our knowledge.

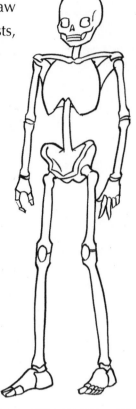

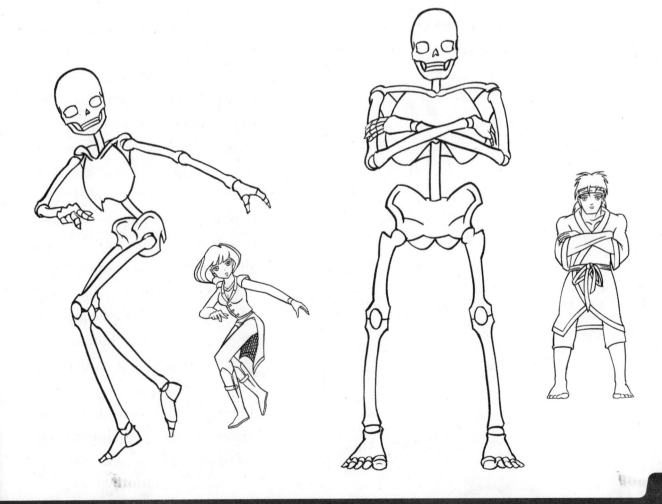

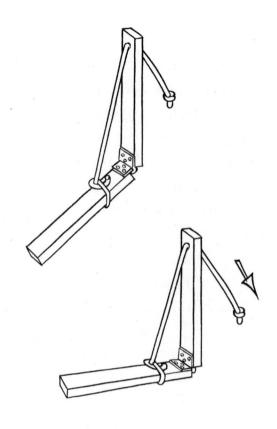

Essentially the muscles move the skeleton. It helps a lot if we understand the basic physics involved. The two-stage diagram to the right shows a hinged stick with a piece of string attached to the lower part. This cord then travels through a hole in the upper part of the upper stick. Pulling this raises the lower rod, much in the same way our bicep lifts our forearm. Unlike the string our muscle is attached by tendons to the bone at both ends. It contracts to lift the arm. The contraction shortens the length of the muscle which also has the effect of widening it.

Muscles work in pairs so that as one tenses, the other is relaxed. The diagram to the left shows this in action using the bicep and tricep muscles of the arm. As one muscle bulges, the other doesn't. Our bodies are a network of muscles that produce movement by complex variations of contraction and relaxation. Learning which muscles are used in any given task will aid your ability to draw. More importantly it will help you to streamline your art, emphasize the relevant and remove the superfluous. The opposite page shows the major muscle groups. The main difference between male and female muscles is the proportion of fast and slow muscle fibers.

A figure with all its muscles bulging may look very dramatic, but in reality it would be very static.

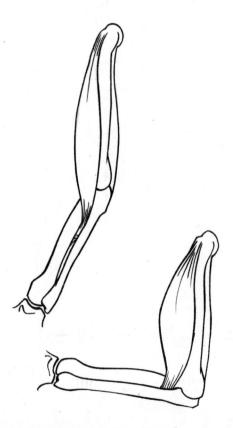

A male has a higher proportion of fast muscle fibers, which are larger. Couple this with the fact that males generally have larger skeletons and the stereotypical forms are obvious. Apart from these differences the muscle network is essentially the same.

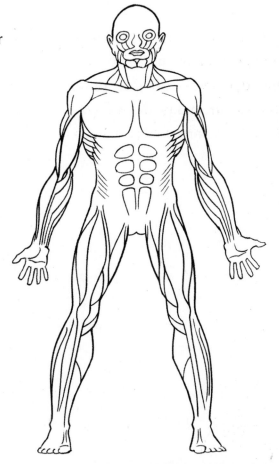

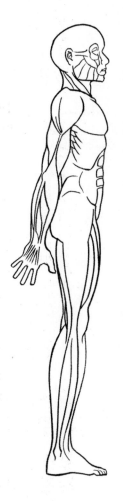

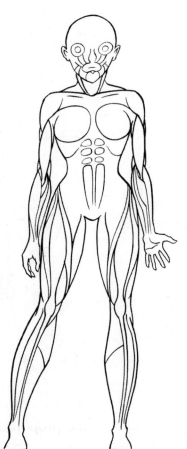

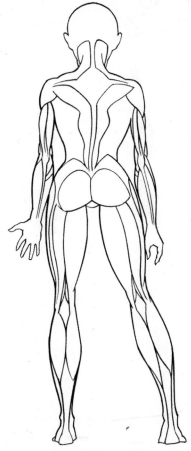

A good way of gaining knowledge of how muscles work is to try and be aware of which ones you are using when doing any simple task.

A line of action is the simplest representation of the figure, the pure dynamics of the pose. Planning an image in this way allows us to pare down a figure's expression to its essentials. If these one or two lines do this, the rest is simply a matter of "hanging" the detail onto this frame.

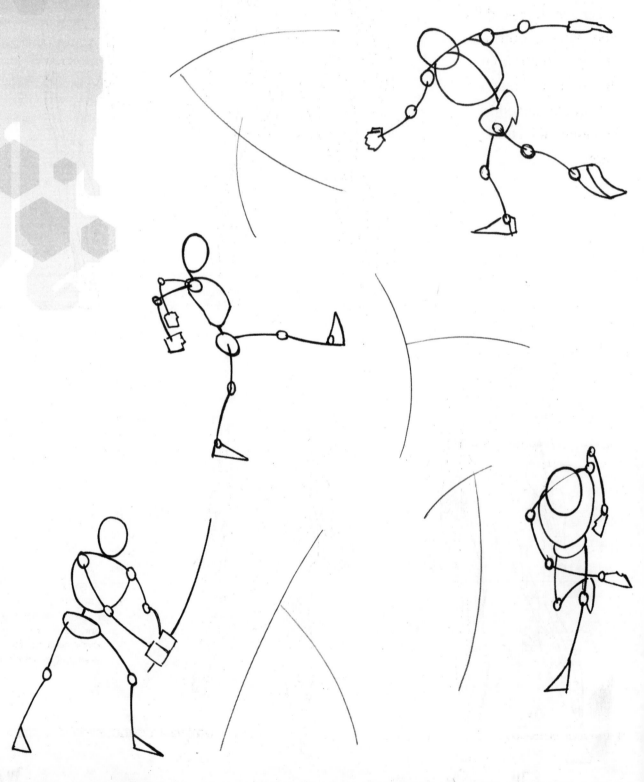

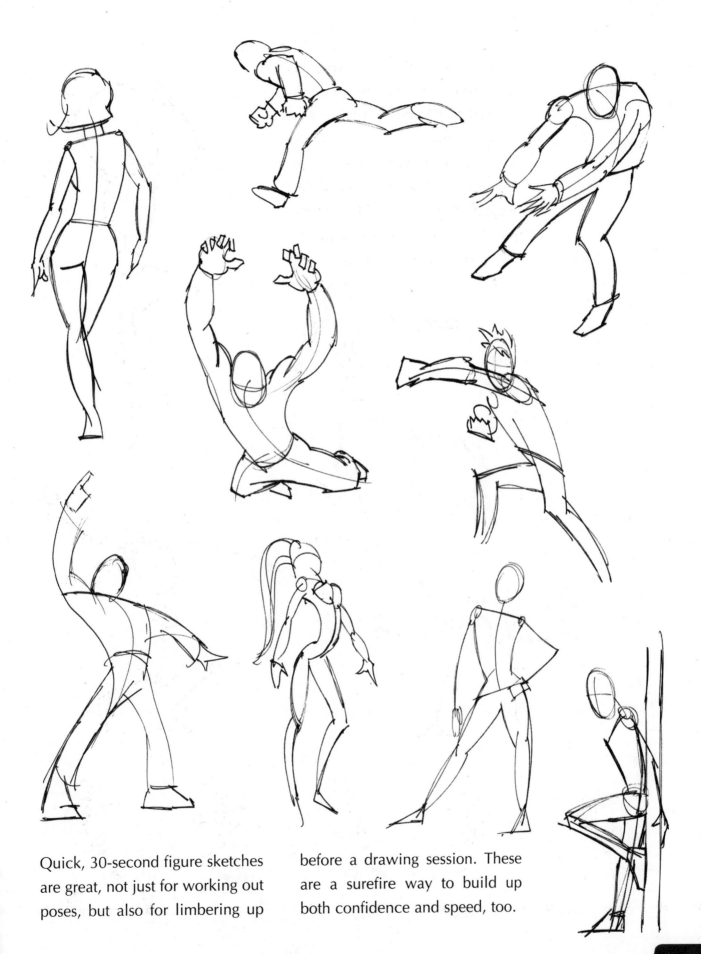

Quick, 30-second figure sketches are great, not just for working out poses, but also for limbering up before a drawing session. These are a surefire way to build up both confidence and speed, too.

When drawing figures, always try to consider the balance, point of contact and weight direction in a pose. At the bottom is a series showing a running figure. The arrow shows the direction of the weight. In all but one of the pictures he is unbalanced, implying a figure in motion.

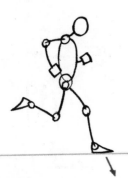
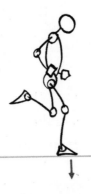
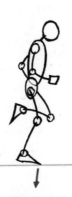
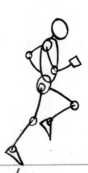
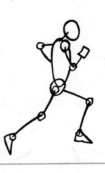

The dynamics of a pose change when two or more characters interact. The top right character is off balance and in danger of falling, but with a little support from his friend (below) balance is regained.

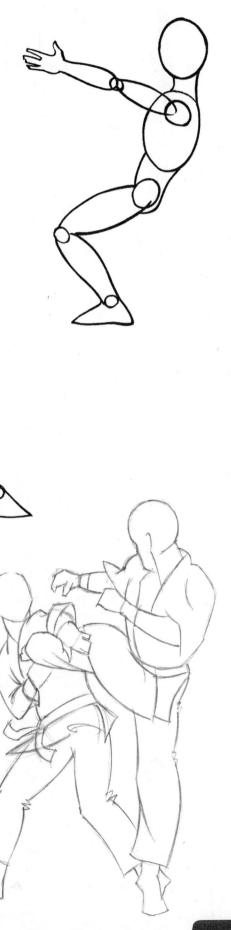

The real art is in the first few lines.
The rest of the image, the detail
and working up, is mainly craft.

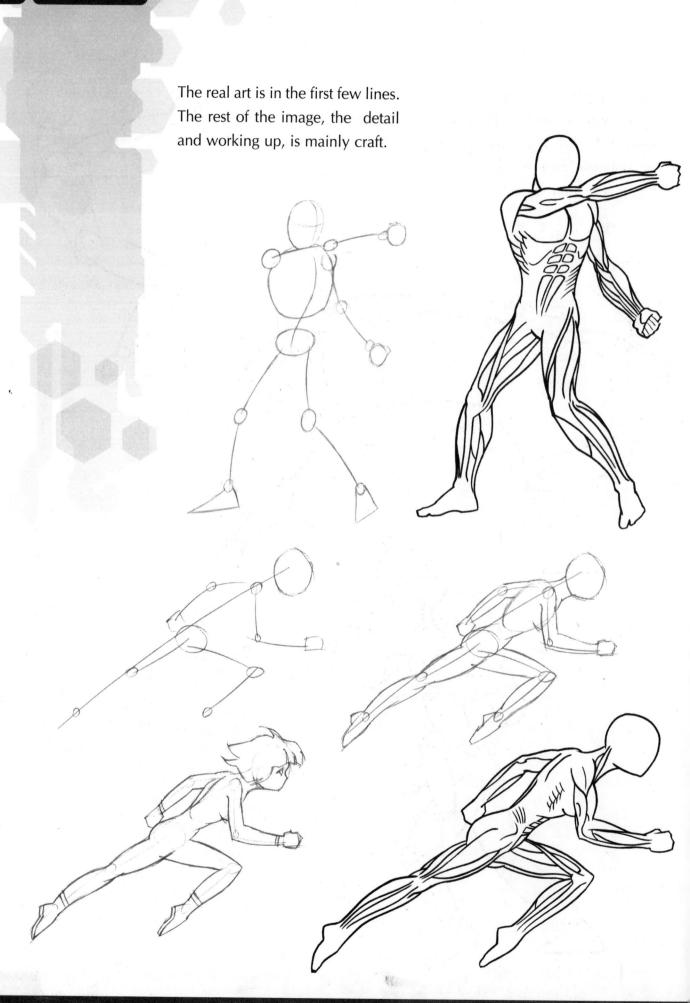

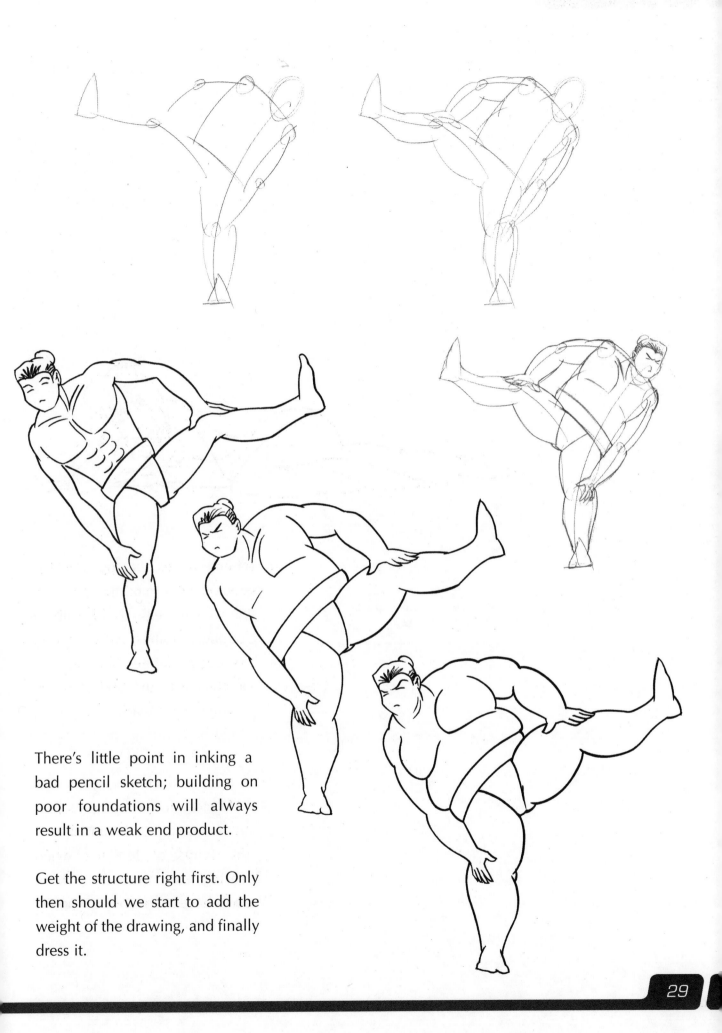

There's little point in inking a bad pencil sketch; building on poor foundations will always result in a weak end product.

Get the structure right first. Only then should we start to add the weight of the drawing, and finally dress it.

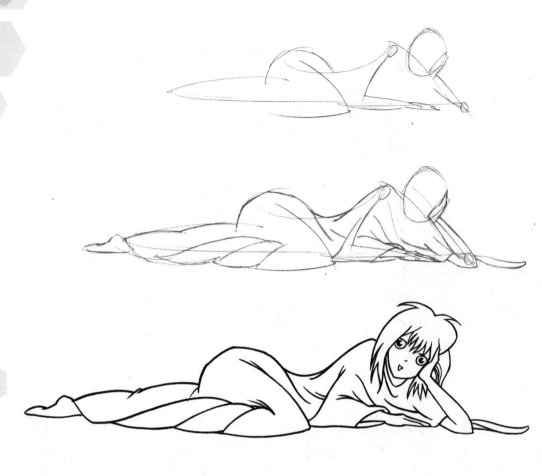

When we've put together the skeleton, the muscles and the skin we can begin to think about clothing. Clothes, when worn, are not separate objects, but interact with the body forming lines and curves.

Fabric is more likely to form folds and curves when it is held close to the body, such as at the waistline with a belt or at the joints of the leg when wearing tight trousers. These curves have a tendency to "point" towards the area of restriction.

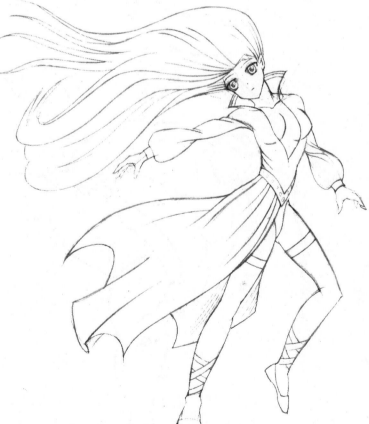

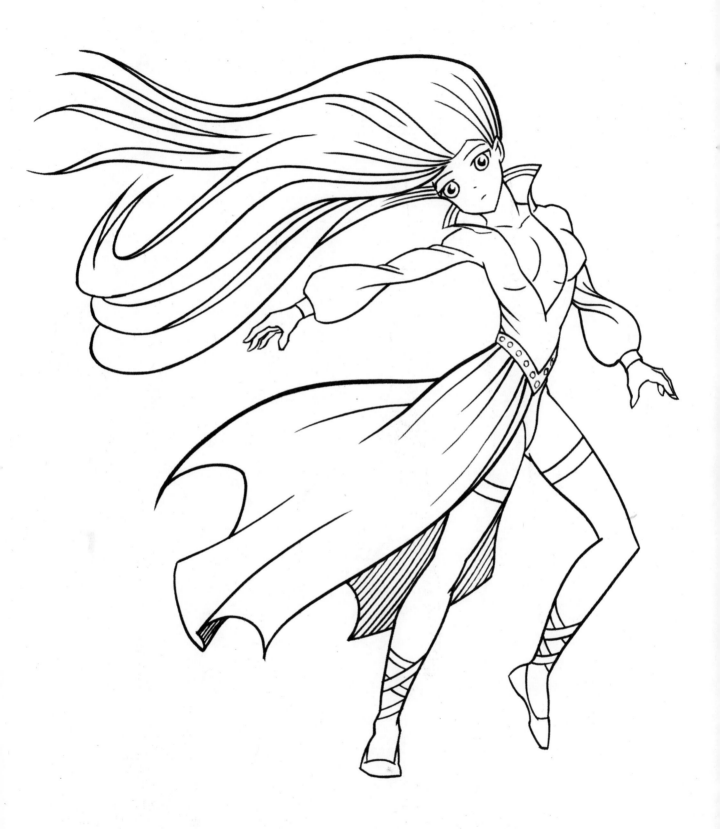

Although clothing and other fabric is hard to master, there's a huge amount of source material to study. Consumer magazines and movies are perfect for picking up tips.

There are two main problem areas when drawing the figure which often spoil otherwise competent drawings; the hands and the feet. They are the most intricate components of the human body, with a disproportionately large amount of bones. With a basic understanding of the structure, drawing hands and feet becomes much easier.

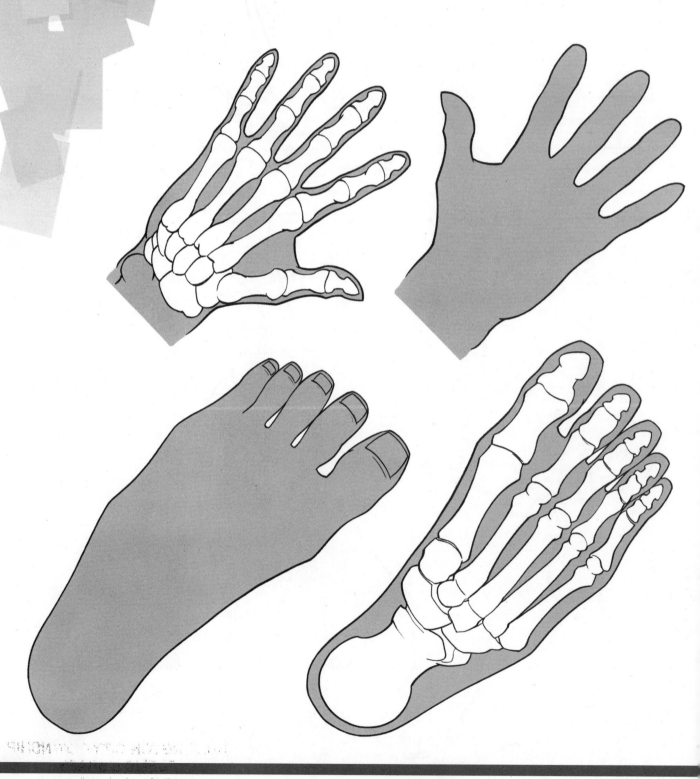

The foot is designed to bear the weight of the body. The sole has a thick covering to protect the tendons and bone. Tendons are more visible on the top because they are closer to the surface and don't need such protection.

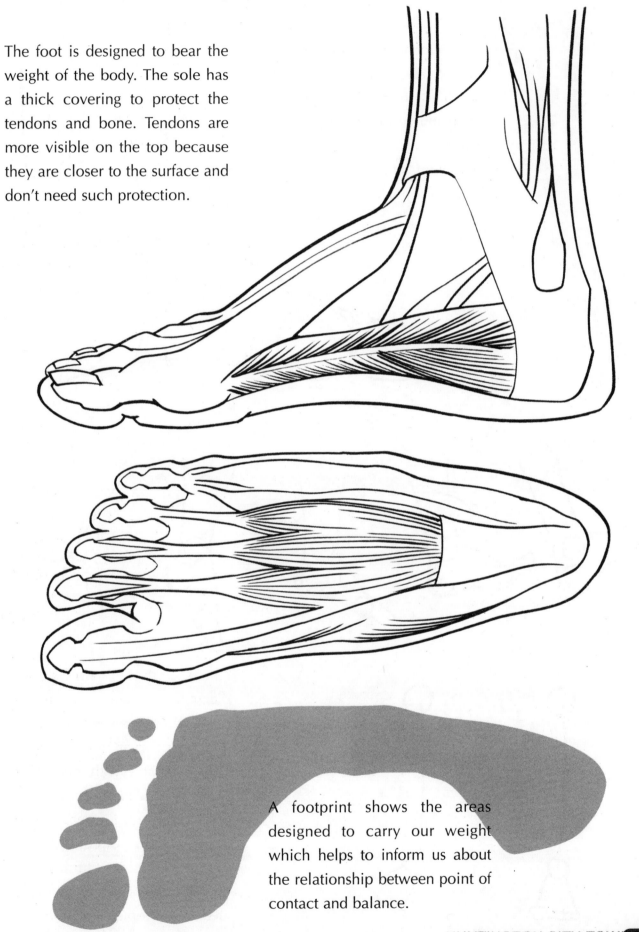

A footprint shows the areas designed to carry our weight which helps to inform us about the relationship between point of contact and balance.

The important parts of the foot are the heel, ankle, ball of the foot and toes. The form is essentially constant, save for the flexibility of the toes. The main movement of the foot comes through the ankle. Which – as we

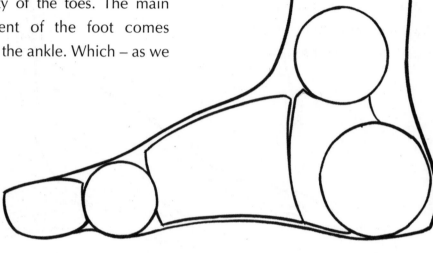

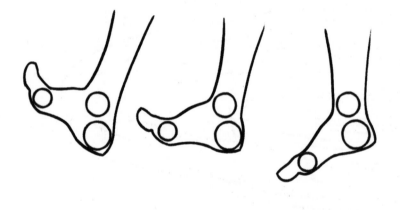

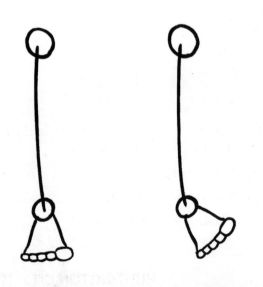

can see through the central diagram – has a range of about 90 degrees. Movement in other directions is even more restricted. This correlates with our earlier footprint showing that the foot is only designed to bear weight from certain directions. For example, we cannot turn our foot outward; our insteps have no meaningful contact with the floor.

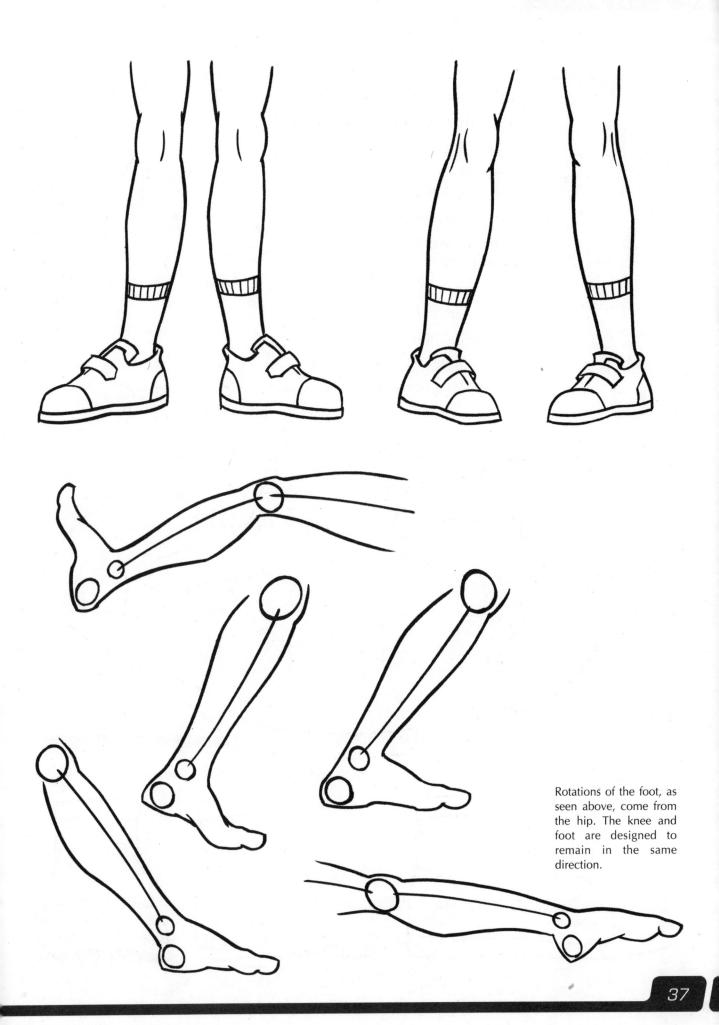

Rotations of the foot, as seen above, come from the hip. The knee and foot are designed to remain in the same direction.

The foot is often covered and this is when understanding its form is most important. Shoes are not boxes stuck at the ends of our legs, they follow the shape of the foot. Although they simplify the form they should still follow it. The principles of weight and balance still apply but may be altered for some shoe structures, most notably high heels.

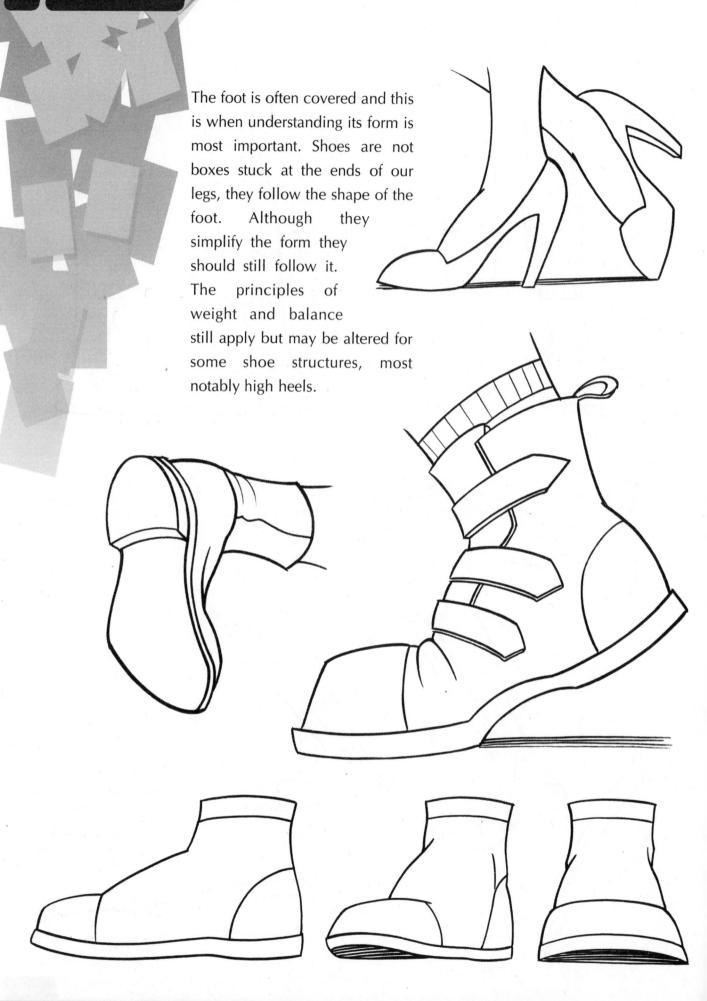

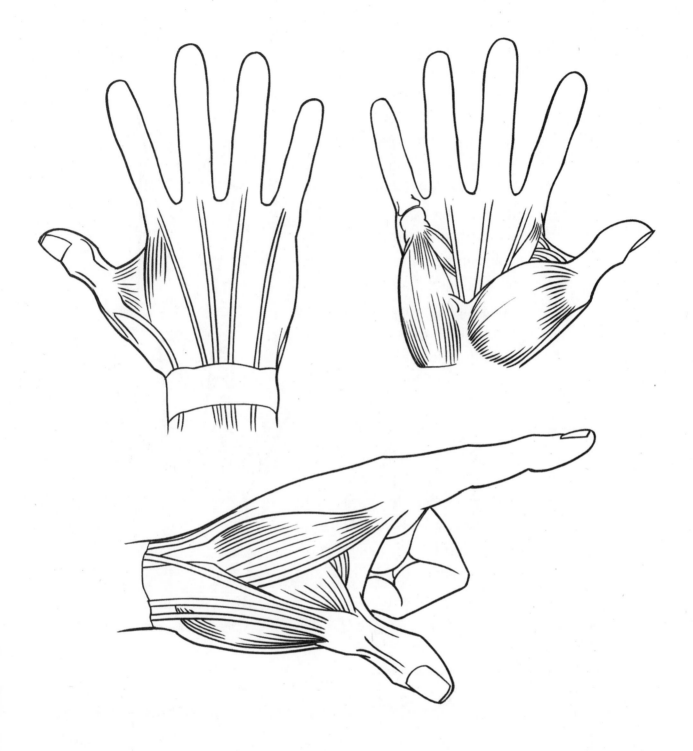

In many aspects the hands are similar to the feet. Tendons and bones are most visible on the backs, whilst the palms are covered with a leathery skin. The construction of bones and muscles vary dramatically in proportions, but are of similar design. The biggest difference comes through usage. Our hands perform a great number of tasks, necessitating longer more agile fingers. There is much more flexibility than with the foot and so the form is much more variable.

If in doubt, don't forget that the best hand reference is right there, at the end of your wrists!

In its simplest form the hand consists of five sticks, side by side, tapering toward the wrist. The palm is essentially a square approximately half the height of the hand. The most prominent joints sit in a slight arc within the top part of that square. Thicken the sticks and you have four fingers and a thumb. Proportionally the bones at the tips of the fingers increase about a third in length each time as they progress towards the wrist. Logically the arc of the joints becomes more extreme from the palm outward. Observing this arc and circling the joints will dramatically improve drawings of hands, and is a trick many artists use, especially for difficult hand positions.

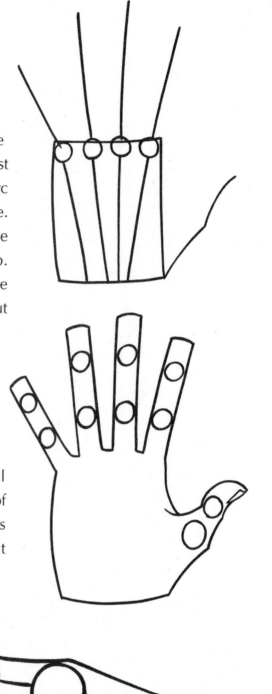

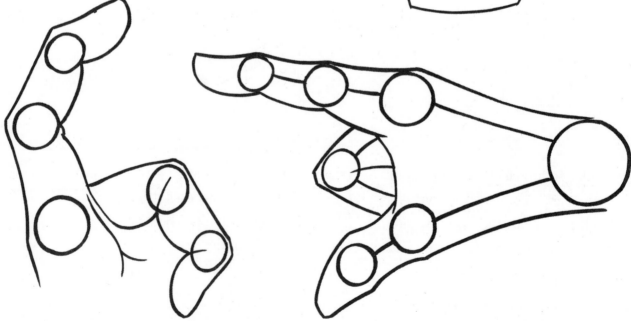

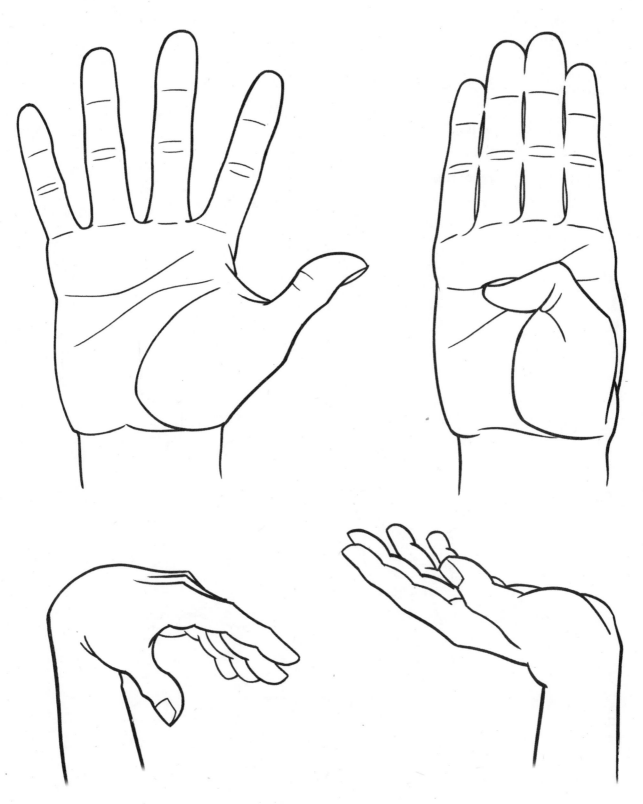

Our fingers are longer than our toes and this allows them to spread much wider. Observation tells us that they bulge slightly at each joint. Unlike the big toe, our thumbs are opposable and can stretch across our palms. The wrist also allows the hand a much greater range of movement, twice that of the ankles.

Although much is gained through observational drawing, it is important to be able to construct a hand in any desired position from our imagination. As mentioned earlier the arcs formed by our joints are useful in hand construction. When drawing a clenched fist the individual

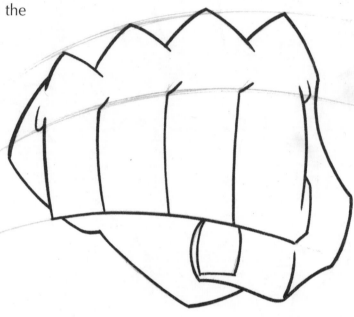

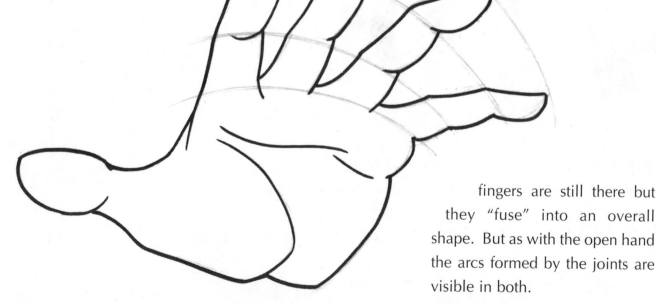

fingers are still there but they "fuse" into an overall shape. But as with the open hand the arcs formed by the joints are visible in both.

The only way to improve this difficult area is to practice. A combination of observational and constructed drawing should move you quickly toward your desired results.

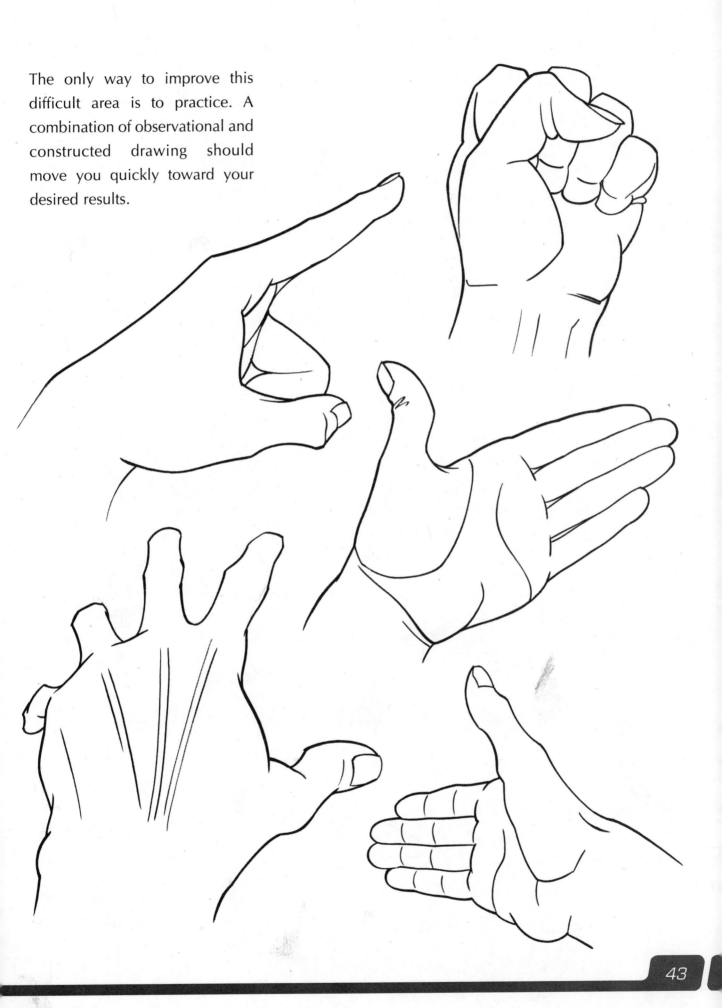

Some artists rely heavily on photographic reference, but we should be careful with this, especially when approaching hands. From many angles or positions a hand is not easily recognisable. For example, the dynamics of the hand change with props. The hand may be contorted or obscured. For an image to be successful we need to be able to recognize it. Even though the majority of it is hidden we can still read the image below as a hand

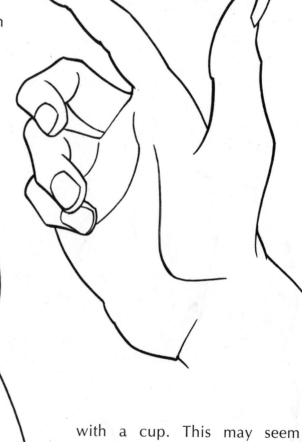

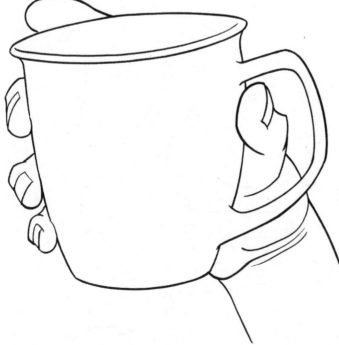

with a cup. This may seem obvious, but is nonetheless very important.

As mentioned earlier, Manga has a huge array of styles and genres. No aspect of the form illustrates this better than the variety of approaches to drawing the human face. To a large extent, the style used to portray the face depends on the subject matter. The exaggeration of certain facial features helps to convey a character's personality.

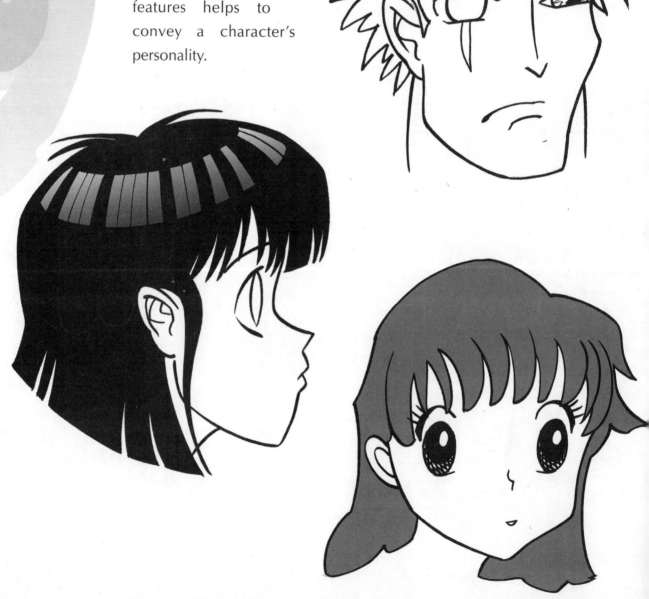

A cute or kawai strip, such as those typically found in shoujo Manga, is likely to feature characters with big, gooey eyes and tiny or even invisible noses.

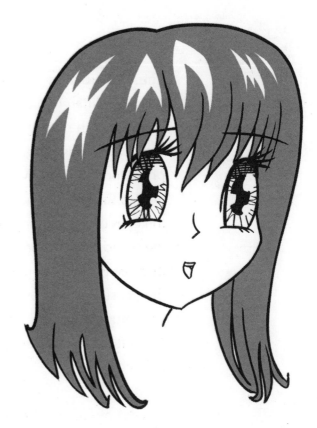

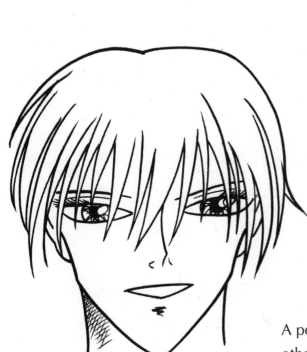

A powerful villain, on the other hand, would exhibit almost the opposite exaggerations.

The construction of the Manga head is different in shape from our own. The head you see on these pages is a good starting point for the basic Manga head. Due to the prominence given to the eyes on most Manga faces the head has to be wider than heads in real life. In the case of characters with huge eyes the head may often be wider than it is tall.

If we draw a circle and then cut this in half both vertically and horizontally, this gives us the basic template onto which we can start adding the features.

We then need to construct the

chin and jawline as in the image at the bottom left. Before we add

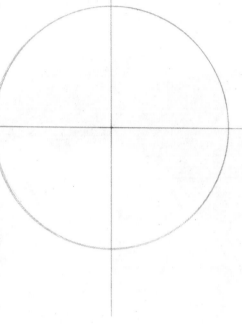

the eyes, it's a good idea to make sure we draw them far enough

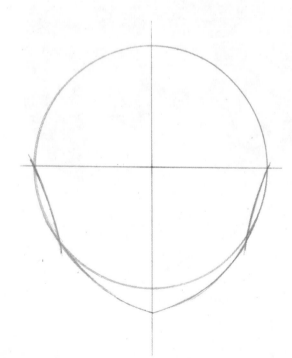

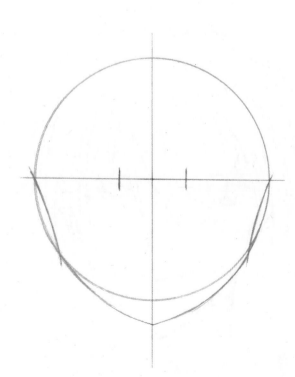

apart. Put these two marks along the horizontal as shown. The distance between them should be roughly the same as the width of one eye.

Next, we'll start to put in the eyes as in the image to the right. The upper eyelids in this example form two arches over the horizontal. Eye shape in Manga differs widely, but just use simple circles for now.

Now comes the ears, nose and mouth. In a head-on drawing, the top of the ears should be roughly the same height as the upper eyelids, with the bottom just above the jawline.

Hair, eye detail and eyebrows are all that's left to complete our first character's face.

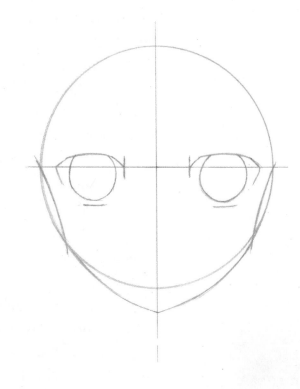

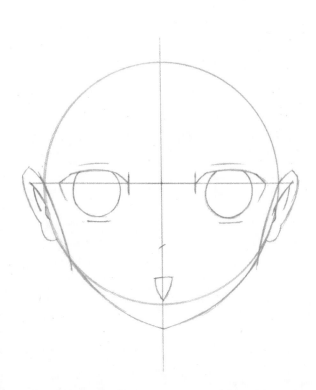

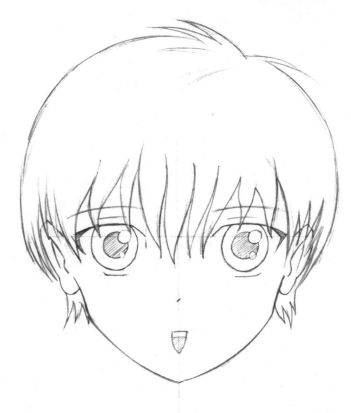

Although this three-quarter position looks more difficult than those on the previous page, it works on exactly the same principles. All that's happened is our vertical line has been moved to the left. What we have to watch out for is the jawline and the position of the eyes. At this angle we can see how the jawline meets the bottom of the right ear and then changes angle to sweep down towards the chin. The left jawline is simply a narrower version of what we drew on the previous page.

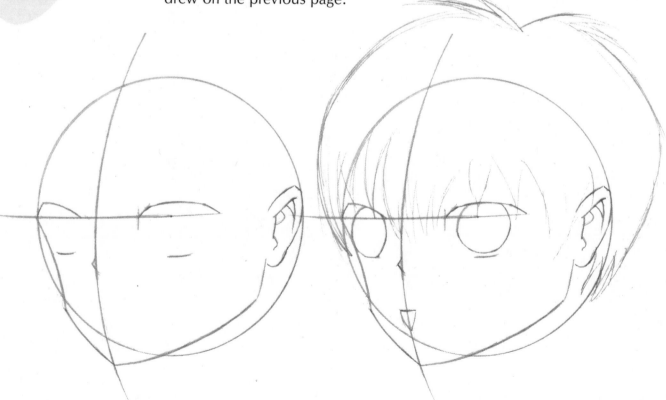

Another potential pitfall is the shape of each eye. The right hand eye is now located about halfway between the ear and the nose line; easy enough. But the left hand eye seems to have changed quite significantly.

This is now not as wide due to the effect of foreshortening. This effect causes the angle of the eyelid to now be more acute, although we should take care not to draw it any higher than the other eye. The change in viewing angle also makes the eye more oval in shape.

Notice that the curves in our character's hair change as well. These should always loosely follow the shape of the head. More on hair later.

Getting our heads to look correct from this angle can take a lot of practice. If things are really going wrong remember the golden rule: simplify. If you can't get it to look accurate with a semi-realistic face like this one, then try a much simpler model until you fully understand the principles involved.

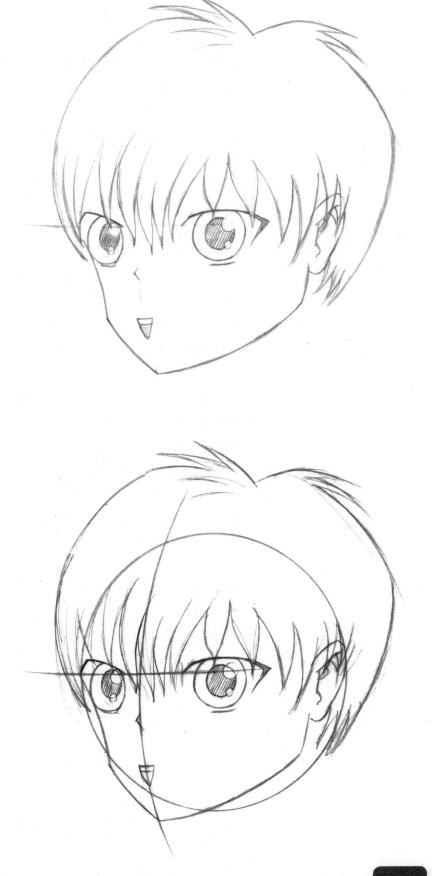

The profile is different from other angles because in these drawings there is no meaningful vertical line. Obviously this is because the center line of the face is now located at the extreme right of our drawing. The main thing to master first is the position of the ear and eye, located along the horizontal line as below.

In profile the eye is a rather different shape. The eyelids now form a sideways "V" shape.

A common mistake when drawing heads in profile is not drawing the head wide enough. There may well be more distance between the ear and the back of the head than you think.

In Manga the forehead is nearly always located behind the front jawline. In some extreme versions, this effect is heavily emphasized, resulting in an almost canine appearance.

The images below show how a proper understanding of the last few pages should enable you to draw any head from any angle. If the basic construction is good, the rest should be easy. Try making up your own angles, starting with simple ones.

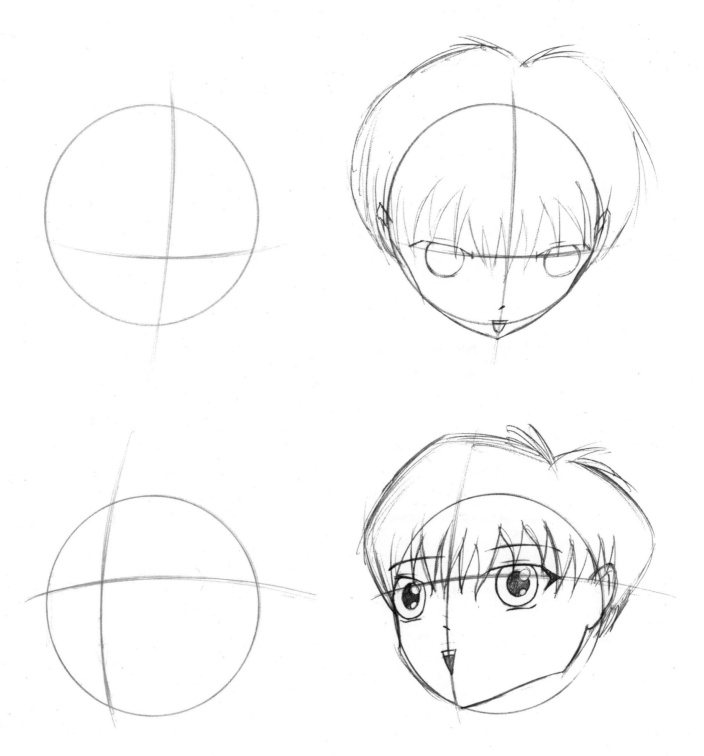

OTHER HEAD SHAPES

These next two head shapes are commonly found in Manga and are simply basic variations on the standard head shape of the last few pages.

The "almond" shape is often used to depict adult males. It's made in much the same way as the previous example but the chinline is extended down. This allows our character to have a longer nose and a more adult look.

There is another example of this style on page 49. In that, the eyes are narrowed to produce a typically seinen style look.

Once we've got the structural basics drawn, we can begin to tinker with the detail until we achieve the particular aesthetic we are looking for.

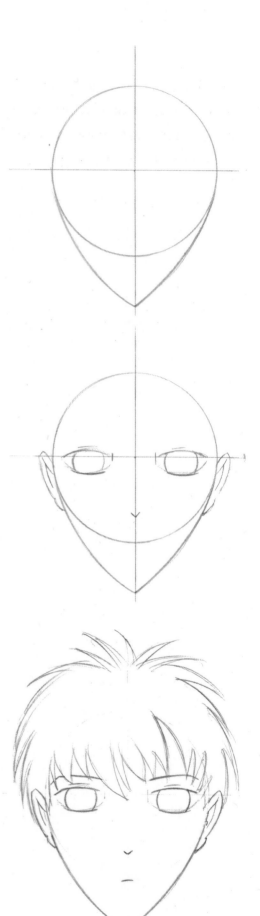

KAWAI TYPES

In typical kawai or cute type faces the chin is moved up and the eyes down. This has the effect of producing features similar to that of a baby, probably the cutest human face around!

As you can see, the chin does not extend beyond the boundary of the initial circle and the eyelids sit below the horizontal.

Modifications to all of these basic designs may include giving the chin either more or less of a point; rounding off or sharpening the jawline to produce a squashier or firmer shape and radically altering the shape of the eyes and eyelids.

The key to finding our own approach to faces is built around our desire to experiment. For now, try out as many different variations as you can think of and see which ones come closest to your ideal.

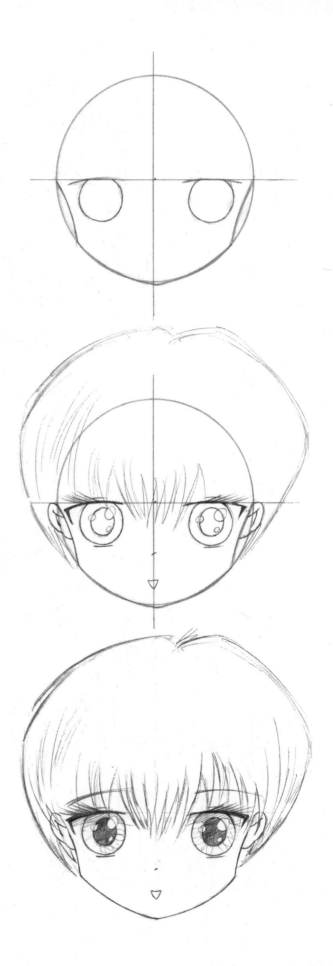

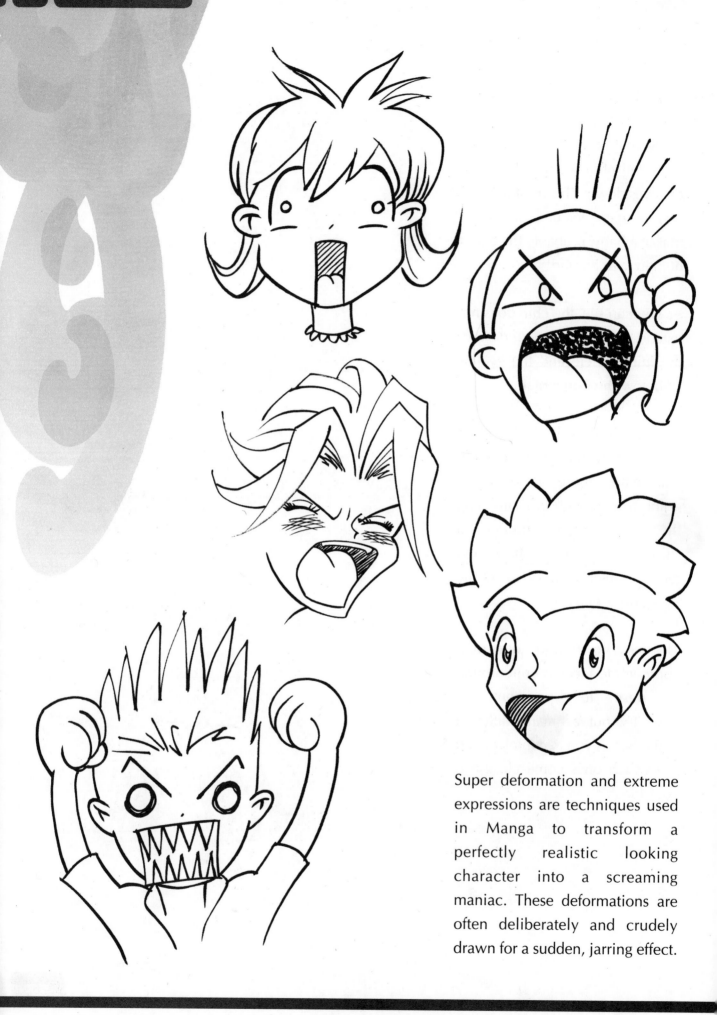

Super deformation and extreme expressions are techniques used in Manga to transform a perfectly realistic looking character into a screaming maniac. These deformations are often deliberately and crudely drawn for a sudden, jarring effect.

HAIR

The hairline which separates skin from skin from scalp has a very distinct shape. This needs to be considered when planning a character's hairstyle. The area immediately around the ear is hairless. There is usually a slight or noticeable "peak" in the middle of the forehead.

The drawings below show that hair doesn't just sprout out of the head at random – it has a particular shape and pattern. Notice how the angles at which the hair grows out of the scalp follows the curve of the scalp as it moves towards the crown.

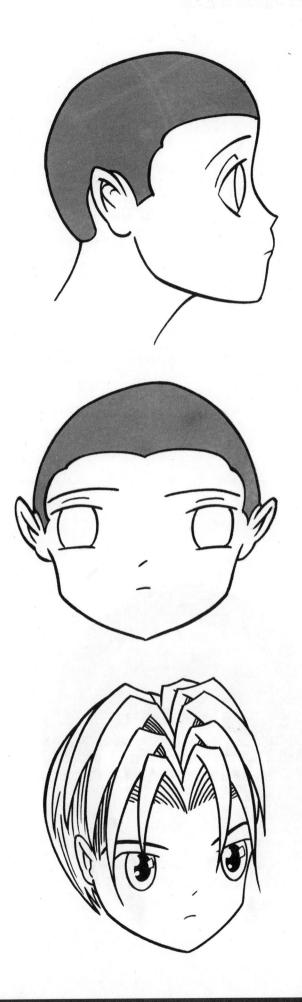

Simple, straight hair is easy to apply shine to. The key to this is to keep in mind that the pattern we put on the hair must follow the shape of the head. This way the mind "reads" the pattern. This is what makes the hair look convincing.

It's a good rule to try to achieve the maximum result with the minimum lines when adding light effects to hair. Overcomplication will only make the image harder to read.

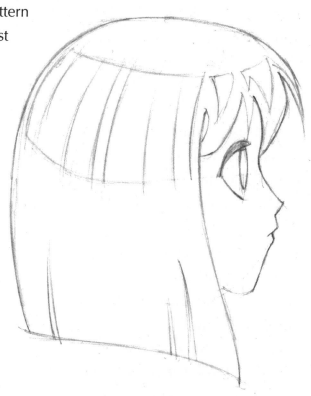

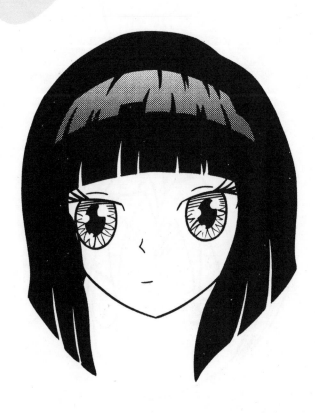

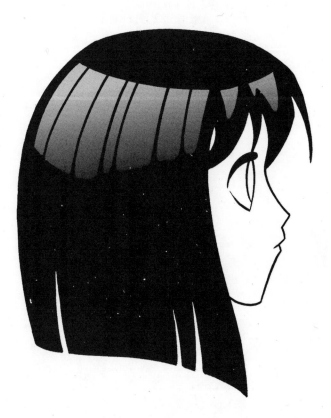

Long, flowing locks require patience and planning. It's all too easy to get ourselves in a mess with this type of image.

Try to avoid conflicts in direction. Although there's a lot of hair here, it is all flowing in much the same direction, helping to give our image unity and readability.

Drawing hair, especially when it is long, requires a very steady hand. If you feel the quality of your linework isn't quite up to the job, practice drawing simple, long, flowing lines until your confidence improves.

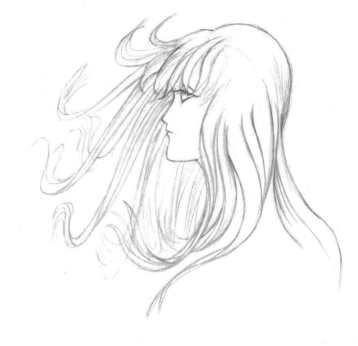

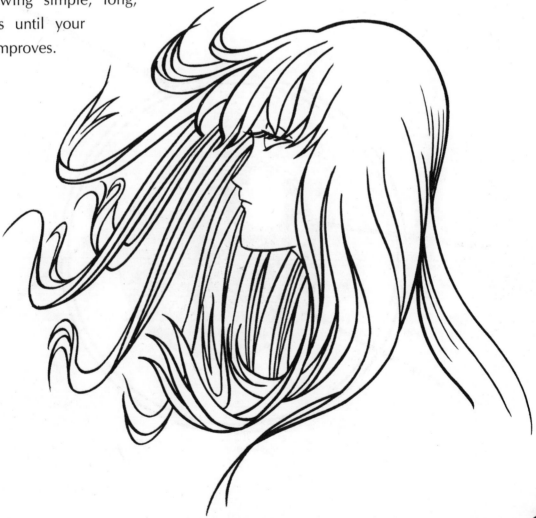

Manga has devoted more time and energy to the possibilities of eyes than any other art form. Bigger, deeper, wetter, brighter – everything about the human eye has been exaggerated to the maximum.

But how is an eye actually constructed? Understanding the biological and physical facts will be a big help in improving the rendering of the human eye. There are four main components to consider, shown below.

The cornea is the outer casing of our eye, the part that reflects the light.

The white is the main body of the eye. The iris is the colorful, mysterious middle ring and the pupil is the expanding/contracting central hole through which light passes. Learning these terms helps us understand what we are trying to draw.

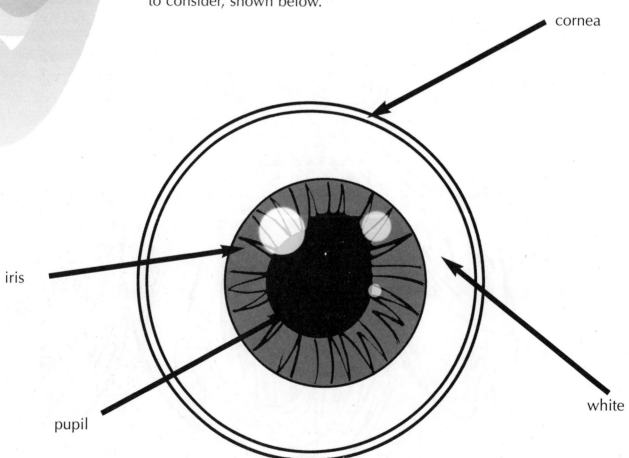

cornea

iris

white

pupil

Most eyeballs we see in Manga, at least the larger ones, are drawn with the aid of either tone sheets or a graphics program. For the benefit of those with neither, here's a way to create an eye with lots of depth, using only black ink.

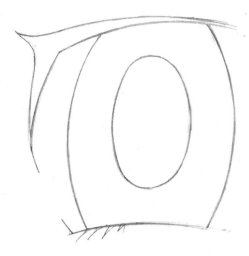

1: Establish the main areas

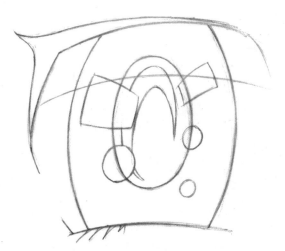

2: Work out where to put the light and shadow

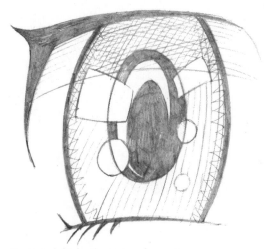

3: Establish the tonal areas

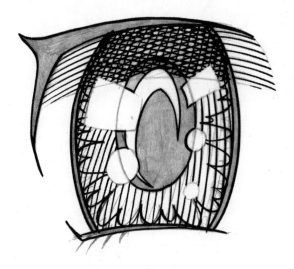

4: Apply the ink carefully

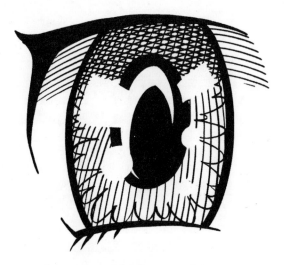

5: Ink in large black areas last to avoid smudges

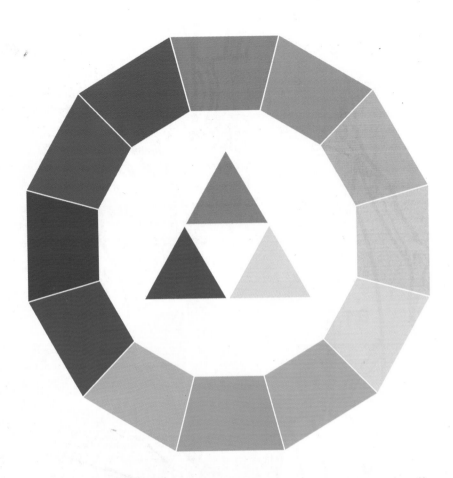

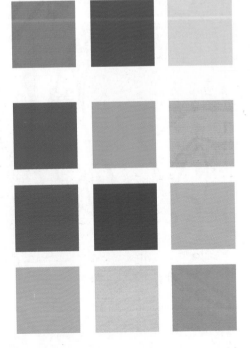

The diagram above is known as a *color wheel*. Its function is to clearly show how all colors are formed from the three primary colors – red, blue and yellow. As importantly, it shows us the *relationships* between colors. If you want to know what the opposite of orange is, for example, take a look at the wheel – you'll find that it is blue. These opposites are known as complementary colors and are at the heart of a large part of color theory.

Above: The color wheel.

Top line: The three primary colors.

Bottom three lines: A selection of secondary colors.

Any color made from two primaries is known as a secondary color. These include purple, turquoise and orange. A color containing all three primaries is called a tertiary color. Tertiaries are typically earthy, brownish colors.

Above are three identical pictures but treated using primary, secondary and tertiary colors. It should be quite obvious how the mood of the picture is dependent on the colors used.

Below shows a part of color theory concerned with *dominant* colors. Although these squares are all identical as far as size is concerned, some of the squares give the illusion of being larger or smaller. Opposite shows the same effect using basic Manga.

Optical illusions are not just fun. All artwork relies on perception, i.e. how the mind processes visual information. Understanding this can greatly improve our ability to communicate with our Manga.

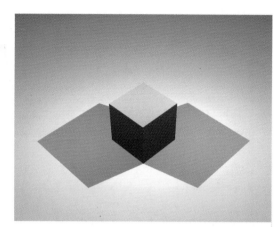

If white light contains the whole spectrum of colors, then shadow is the absence of this. Taking a cube and lighting it from one direction with a blue light we see where the blue light impacts, where it is blocked and the various intensities in between. The same can be seen if we use a red light. However, if we light the same cube with both lights at opposite ends something interesting happens. The area shielded from the red light is not shielded from the blue and only this color is visible. But where the colors meet they combine to produce a mixture; the magenta seen below. The important thing to remember is: light does not behave the same way as paint.

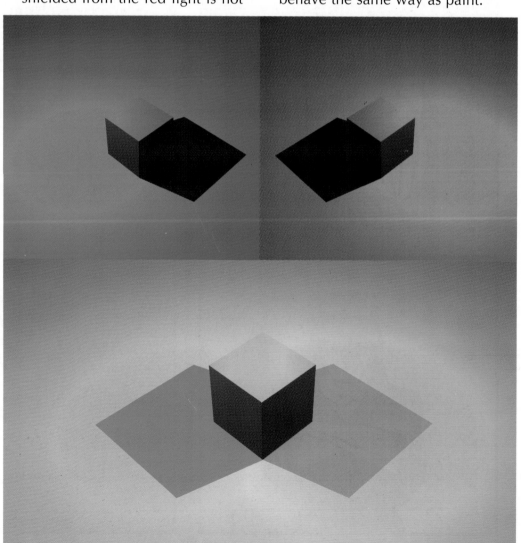

You can use 3D software to experiment with colored light.

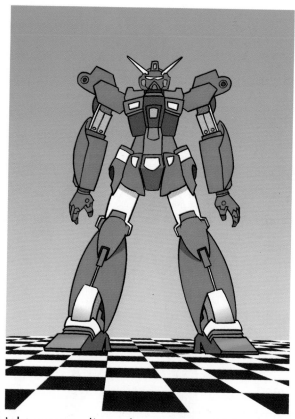

Light source direct from above. This would be the same as direct sunshine at midday.

In low light levels, i.e. moonlight, colors tend to move towards gray.

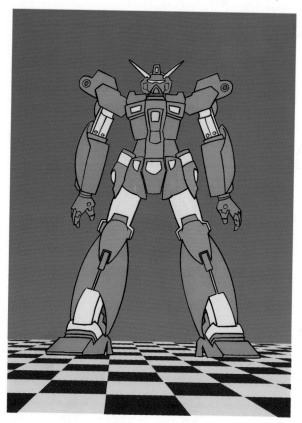

Monochrome lighting: In red light, reds remain strong, other colors diminish.

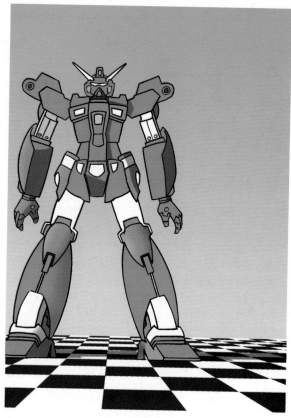

A low-level single light source from the side produces highly assymetrical shadows.

There are many ways to add tone to a figure. Here's one effective method using a shadow map.

Before any toning begins, we should establish the flat color, making sure the balance is right. The further into the job we get, the harder it will be to easily correct the basic colors.

Below is the shadow map, made by tracing over the original line drawing, marking out the areas where the shadow falls. We need to make sure there are no tiny gaps in the shapes we create, as these need to hold the color. Bottom right is the result of applying the map to the colored figure.

This figure is lit with a single light source directly from above. This makes the job of working out the shadow a fairly simple one.

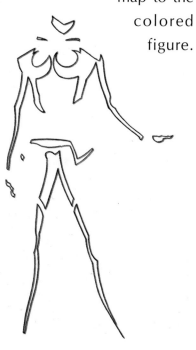

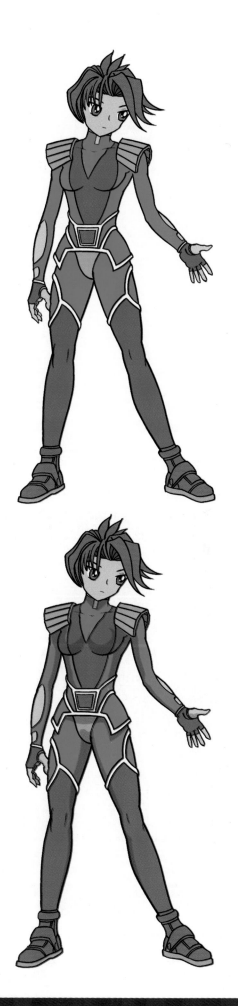

This is done by copying and pasting only the black lines into the figure's document. This will put the shadow map into a new layer. Select the interior of the shapes using the magic wand. Switch to your figure layer. Feather the edges of the selection, then use either the *levels* or the *brightness / contrast* command to adjust the shadow strength of your figure. The rest of the shadowing is a little simpler and can usually be done using the lasso and magic wand in

conjunction with the *levels* and *b/c* commands.

The highlights were created by using a combination of the lasso, the smooth command, feather and an airbrush set to a low output for gentle increases in light reflection.

The hair was also created using similar techniques, but there's a much more in-depth look at rendering hair effects coming up shortly.

Digital graphics programs have a wide range of tools that can be used in a near-infinite number of ways. Everyone who uses such programs develops their own working method. This is a personal technique that will evolve over time. The more we experiment, the more likely we are to discover new ways of achieving the results we are aiming for.

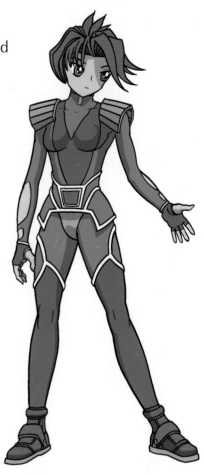

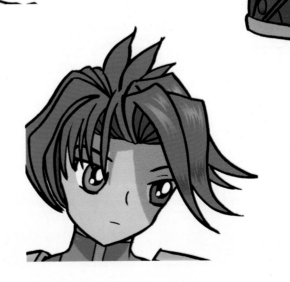

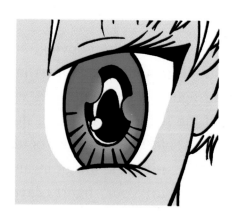

Like shadowing, Manga eyes are usually the result of personal experiment. Here's one method: establish the basic color. I usually use a lighter shade nearer the

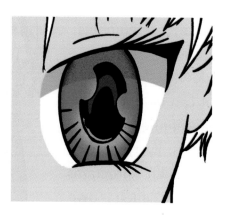

pupil and darker at the rim. Next, we need to get some

speckle and detail into the iris, and add the shadow formed by the brow. We add the highlights only when everything else is in place.

Manga uses "cheats" to get its results. For instance, the upper highlight and deep shadow should not usually be sharing the same space. However, the technique achieves the result without looking unrealistic. If it works, use it!

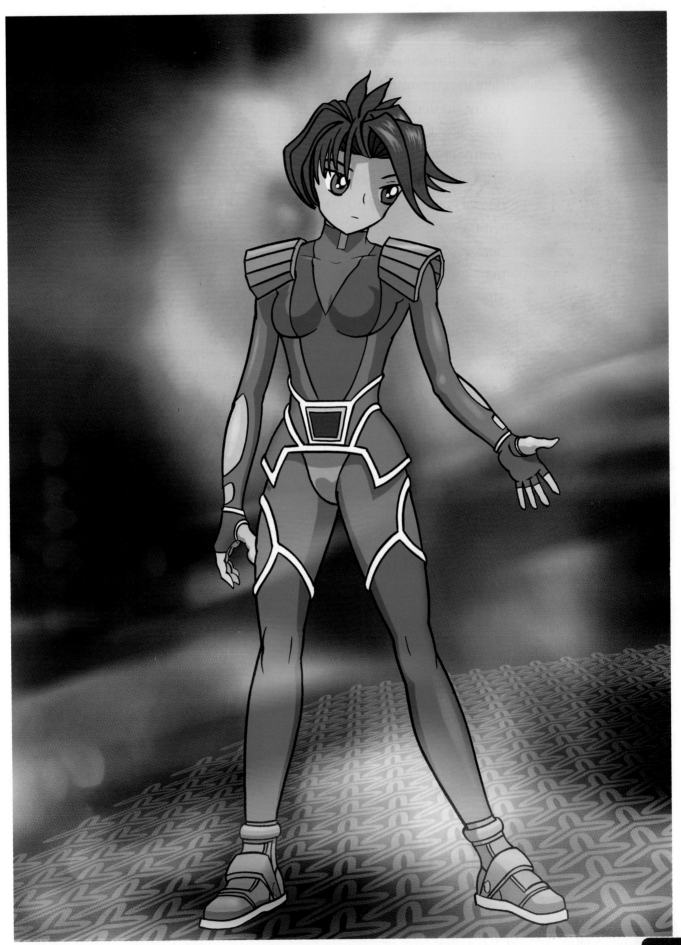

Of all the rendering techniques, hair is amongst the hardest to really master. Like figure toning, there are a number of different approaches employed from artist to artist. Some use a digital pen in conjunction with a graphics tablet, but here's a method similar to that used on the figure. It allows us to completely plan

Copy and paste a section of either highlight or lowlight into your colored image and line it up as below. Be very, very careful that you have placed this pixel perfectly, otherwise the effect will be spoiled, as well as being tough to edit afterwards.

Next , we use the dropper tool to get the exact

where we want each strand highlight before we even get the image in the computer. As with the figure, we should always establish all the flat color before highlighting. Above is an inked overlay of the parts of the hair we wish to highlight. This was done by tracing over the original drawing. You can, of course, put this straight on your original, but it's more tricky to separate.

Having the highlights on a separate layer allows you to experiment with tone and color until you are ready to commit.

hair color into the pallet.
With the whole of your
highlight selected, use the
replace color function to
change the black and
white into the original hair
color. This will have the
effect of making the highlight
layer temporarily invisible, as in
the image to the right. Now for
the fun part. With the highlight

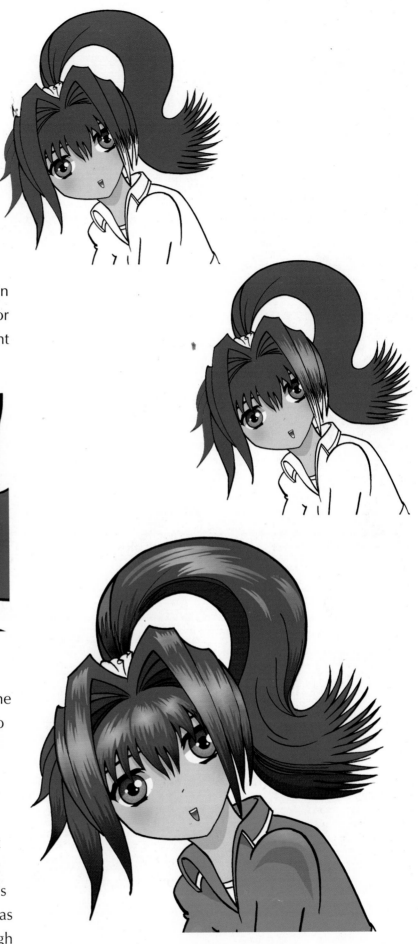

still selected, we can use the
airbrush or gradient tool to
create the graduated effects you
can see at the right and below.
Try it at various strengths until
you're happy. Repeat this
procedure for the lowlights, but
obviously using a darker
version of the hair color. This
technique allows you to get as
involved as you like, using a high
or low amount of hair detail.

Creating our own characters is one of the best aspects of Manga. Whether we favor civilian clothes or outlandish cyberpunk costumes, the creative potential is both huge and rewarding. To do this effectively though, we have to be something of a clothes' designer as well as a competent artist. The right marriage of character and attire is paramount to that character's success.

But let's kick off this chapter by having a quick look at body types and sizes and see what we can learn about these attributes.

The images below show a range of characters varying dramatically in size. These characters are laid out according to a "heads high" system. What this means is that the characters' height is measured not in feet or meters, but according to how many of their heads, when stacked on top of

— CUTE — NORMAL

cute cartoons kids/shojou older kids

each other, would equal their height.

The first and smallest character is three heads high, the last and tallest is a collosal nine heads high. As the captions at the bottom of the page suggest, height is usually dependent on character type.

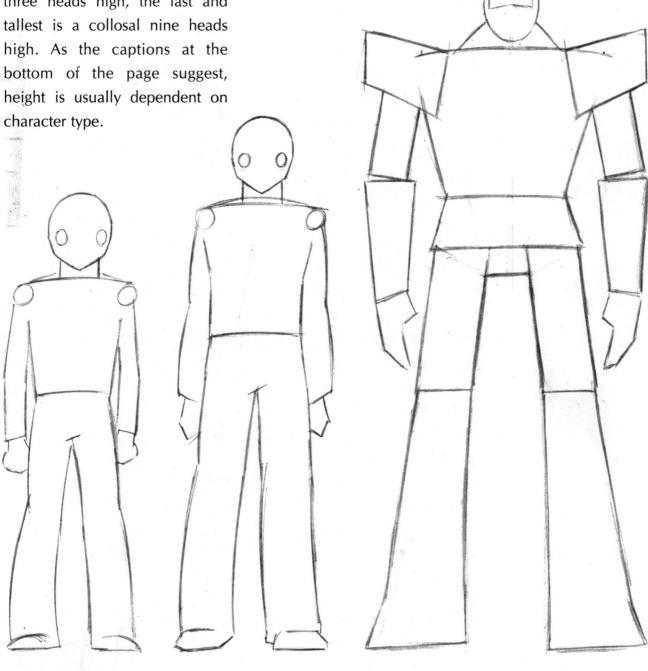

NORMAL ——— IMPOSING —

teenagers adults mecha/monsters

Let's look at the complete development of a single character in some detail. Her name is Berlin and she's seventeen years old.

The image you see here took a long time to create. We usually start with a basic idea and begin to explore its possibilities.

The images on the opposite page are the earliest quick sketch ideas for the character's face, which is always a good place to start. The face is the focus of the personality, and consequently the most expressive part of the human body.

The middle sketch was the first one to be drawn. It captured a lot of what I wanted to create, but was too crude and didn't quite get the look I was searching for. The bottom right was better. I wanted this character to be a delicate mix of the cute and the serious and this sketch captured that pretty well.

The top sketch got nearly everything I was looking for. An alteration to the hair and a light tweeking of the eyes and head shape got the job done.

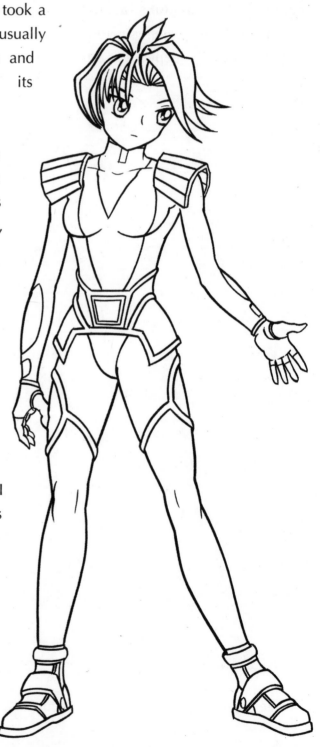

The more specific the idea we have about a new character, the quicker we are likely to hit paydirt. Fumbling around in the dark with no particular thing in mind might be fun, but it's always better to know what we're looking for.

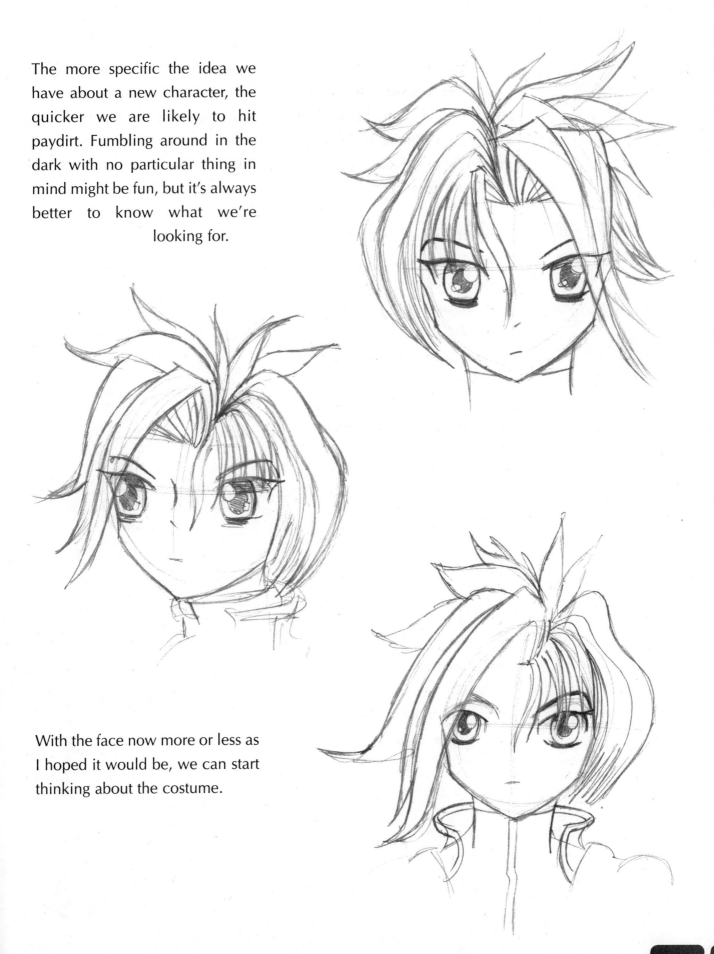

With the face now more or less as I hoped it would be, we can start thinking about the costume.

Working on the kind of clothing we want to see our character in can be a long process. For Berlin, I tried a few quite different ideas, taking the best parts from each.

I experimented with adding a coat for just a couple of doodles before deciding it was not the direction I wanted Berlin to go. She should definitely be dressed in something far more outlandish.

Working with this type of mannequin figure, we can keep the overall impression consistent. This is extremely useful for making comparisons between ideas before starting to mix and match possibilities.

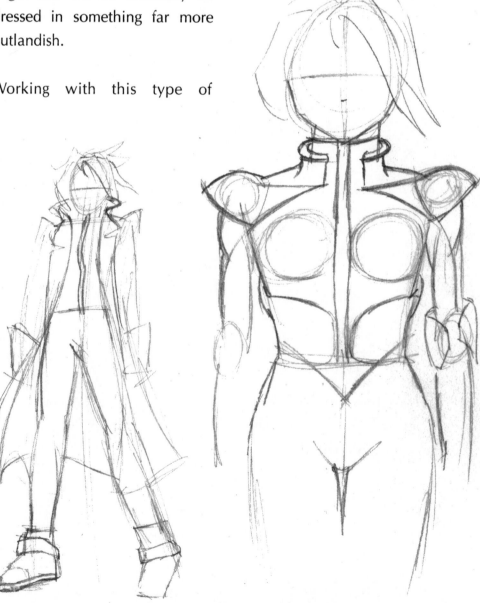

There are some good elements in both of these drawings. As you can see, I experimented with quite a few different ideas for Berlin's epaulets and tried out different armored girdles. This is particularly tricky as it has to allow easy movement whilst at the same time complementing her overall shape and look.

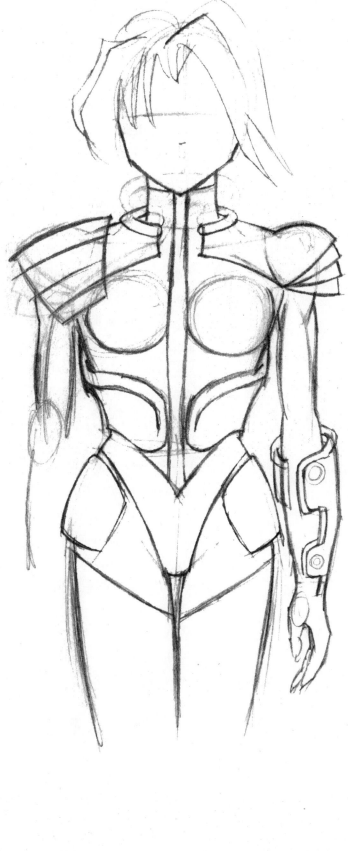

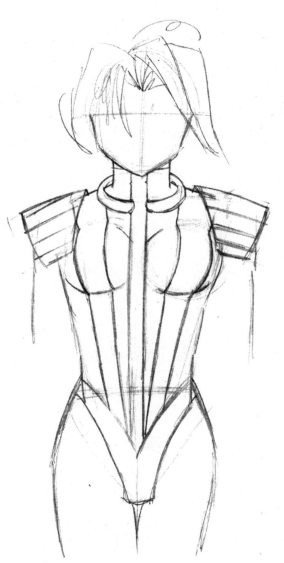

In this image all the elements come together. All of her garments have the desired effect. As you can see, this is a Frankenstein type approach. There's a little of nearly every prototype drawing I did in this image.

The next thing we need to do is try out a full length pose at a more interesting angle. This will tell us if the design really works. If it does not, we would need to make some modifications.

If all is well, we can then go on to perfecting all of her statistics. By this I mean deciding exactly how tall she is meant to be and whether her body shape is right for our needs.

Berlin is seven heads high. This is tall for a girl as it would make her in the region of six foot. Many Manga characters with similar builds are around 75 percent legs.

Whilst this legs-to-torso ratio can be fun to draw, I decided to make Berlin look a little more natural in

her appearance. You can see that her legs-to-torso ratio is quite close to the average woman's.

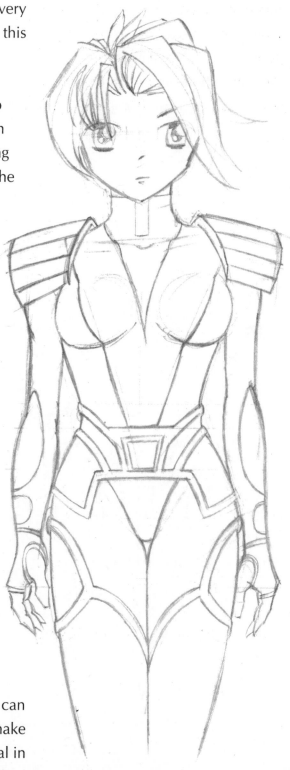

If we're happy with all aspects of our character, there are a few more things we can do to keep the character consistent. These are practices used particularly by anime studios. These methods are a way of making absolutely certain that any character, once fully developed, remains exactly right no matter who draws them.

That isn't the only thing they are good for. Character rotations, or "turnarounds" are the best possible way of giving yourself all the accurate information you could need for drawing your characters at any angle. They are like the frames of an animation, taken whilst the character turns on a moving platform.

The other indispensible device for making your character development complete is the model sheet. These show aspects of our character such as clothing details and their range of expressions.

That's all coming up.

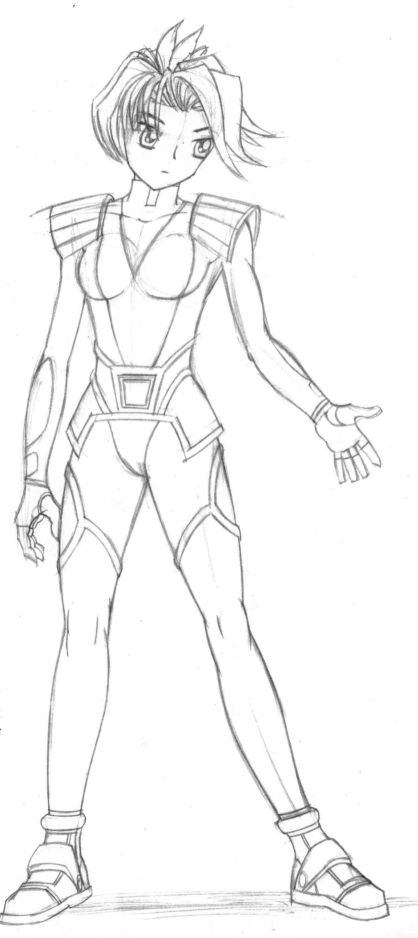

Below is a "turnaround" or "character rotation" shown in its most simple form. The figure is just a basic skeleton at this point, but we can see the idea involved.

At first, drawing turnarounds for our characters can seem quite daunting, but stripped down to the most basic components, we can see all of the mechanics.

The lines running through the figures represent the major "moving parts" of the body. Once the first figure is drawn, it's then simply a case of working out what we are going to see as the character rotates.

Look at the shoulders. In image one they are at their widest apart. In image three they are on the same place on the paper.

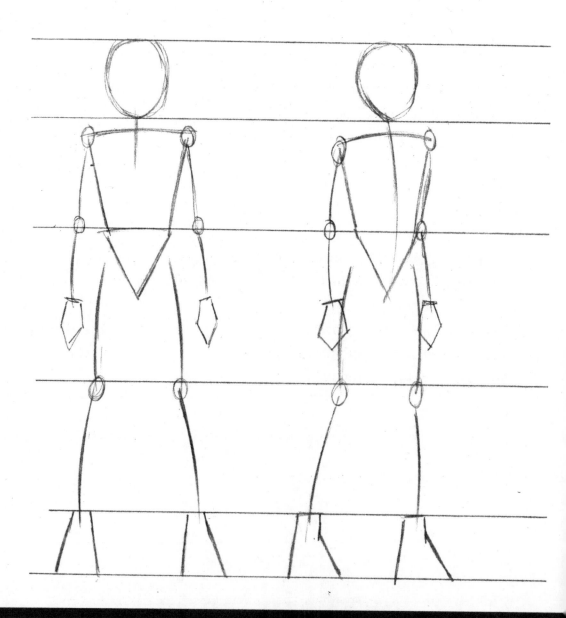

If we can grasp the mechanics of this one concept, we understand turnarounds.

This is the most important stage of the character rotation. If we can get these simple principle drawings right, everything else is essentially "hanging" the body on the frame.

If you are still having difficulty making your own turnaround, try drawing the first and third images and then working out the midway points between them.

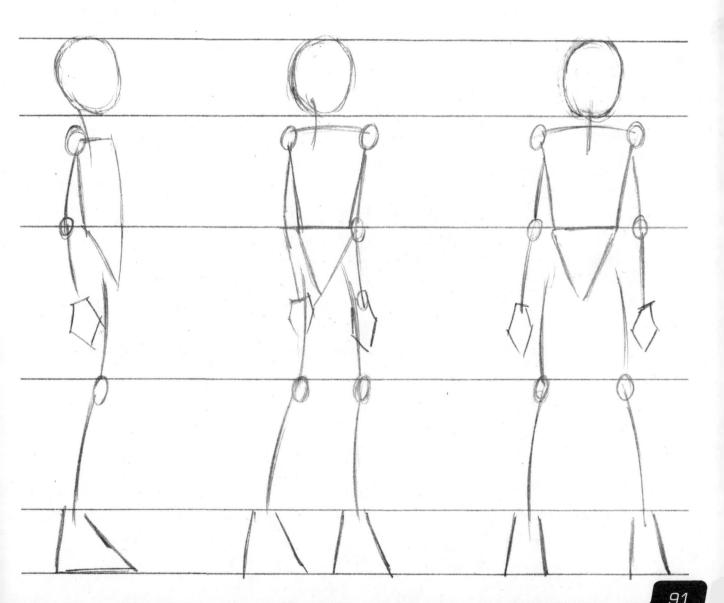

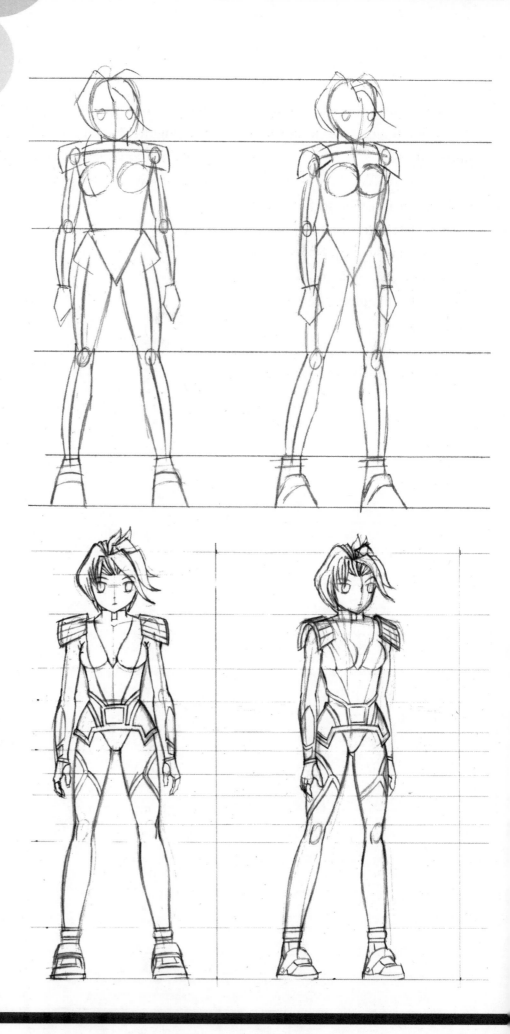

These images show how character rotations are evolved from basic skeletons to fully finished characters.

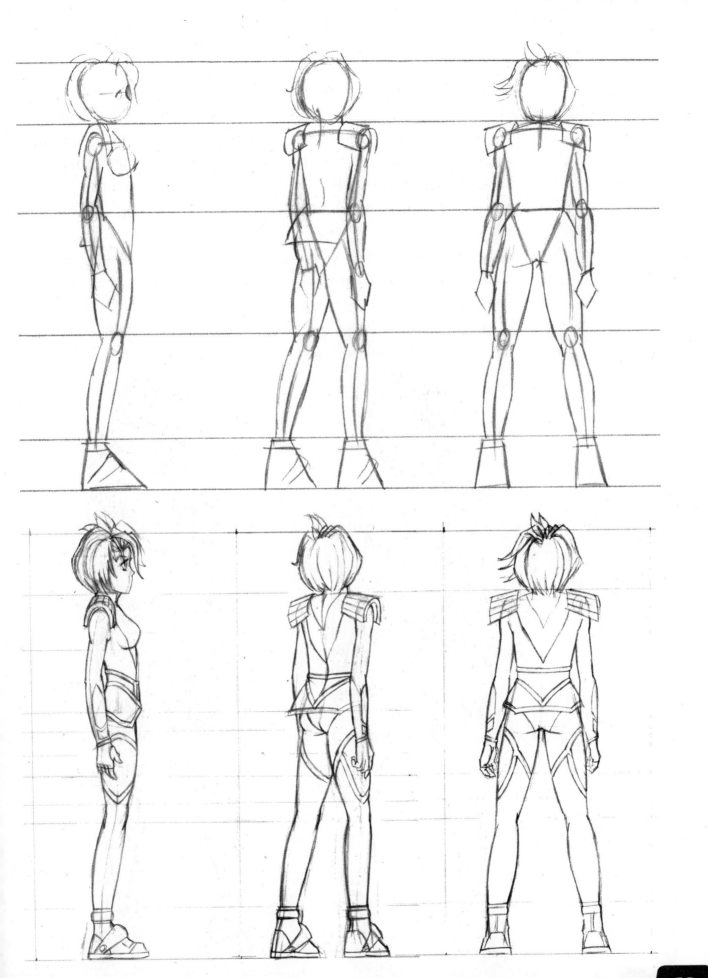

Here is one of the end results of our character creation, a fully operational turnaround. Note that the character does not turn the full 360 degrees. This is only usually necessary with highly asymmetrical characters where both sides of the body need to be shown.

When ever I need to draw

Berlin from any angle I can now refer to this set of drawings to make sure I get everything right. Her costume is quite complex and there's a lot to remember.

If we start to use our character in a Manga story before they are fully formed, the chances are they will start to "mutate" on the page. Little changes will slowly become big changes and before we know

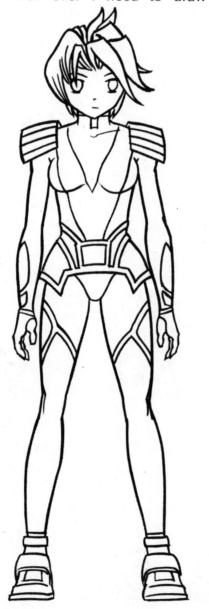

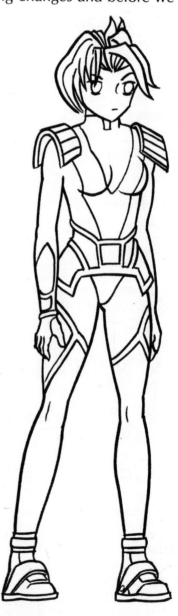

it, the character is very different on page 20 than it was on page one. This is potentially very confusing for the reader, or in the case of anime, the viewer.

These details are worth practicing. As well as the consistency factor, it does our drawing no end of good as it gives us nowhere to hide.

We can't "fake" a turnaround; it either works or it doesn't. As a Manga artist, this is the best discipline you can give yourself.

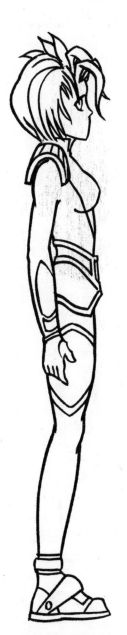
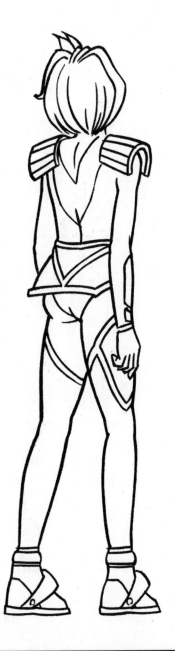
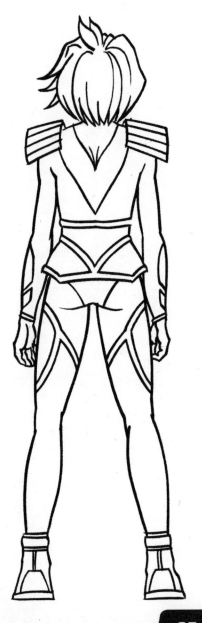

Berlin Model Sheet: Expressions

This is where we lock down all the important details of a character.

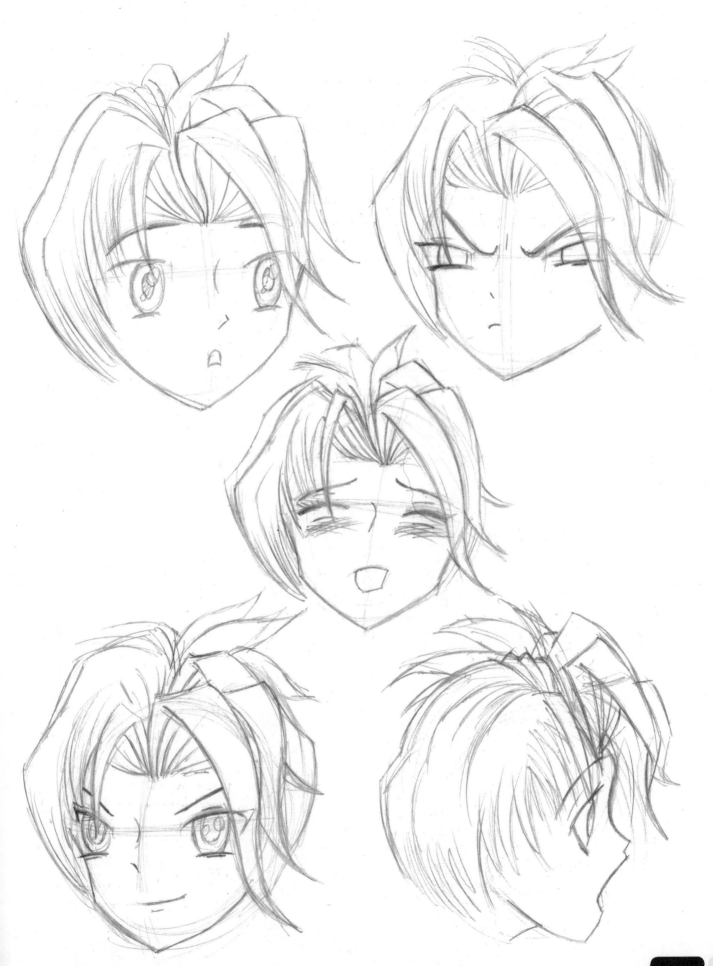

Let's have a quick look at creating one of the mainstays of Manga and anime; the male martial arts character.

This is the single most popular character type in the history of the genre.

We'll create a particularly beefy version of this type, very thick-set with big bones and well developed muscles.

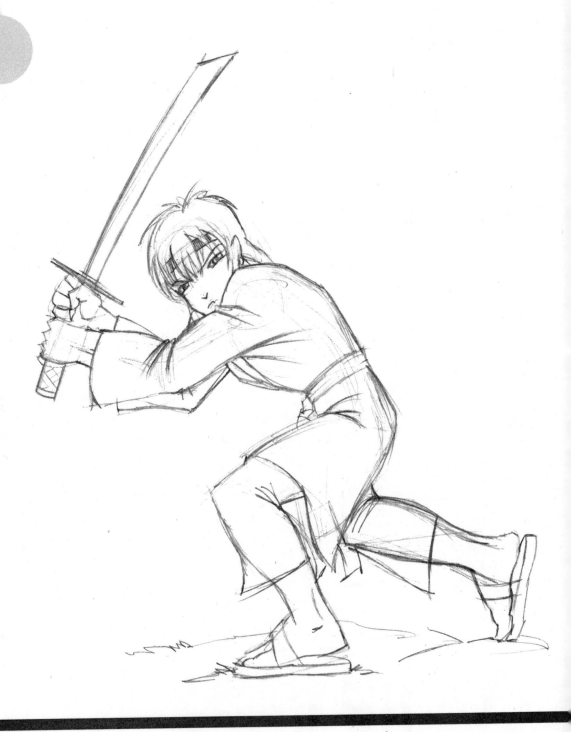

These are the first sketches I came up with for this character type. One thing to watch out for is making sure his clothes don't look like a bath robe!

As you can see, his eyes aren't quite right yet. I wanted this character to look inquisitive and sharp-minded, as in the sketch on the page opposite.

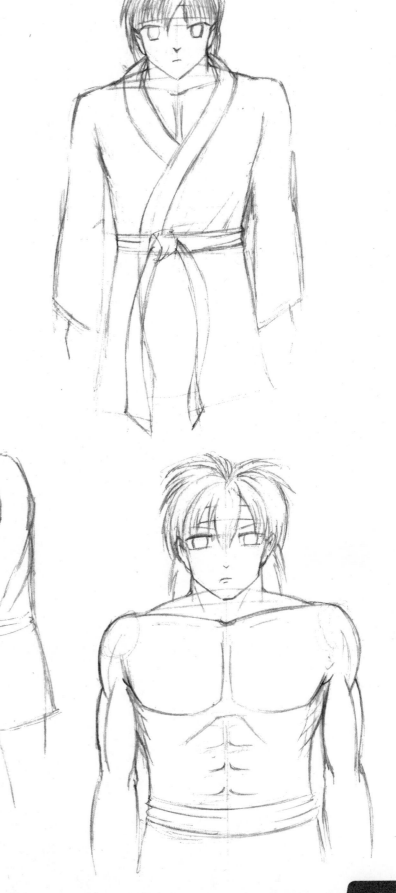

This character is seven-and-a-half heads high, which is around six feet and four inches. His broad shoulders and thick-set body make him appear slightly less tall that a skinnier version might.

These profile studies help us establish a feel for the overall character.

The opposite page shows our character with and without his clothes. Being a martial arts dude, he is likely to spend a fair amount of the time with his shirt off!

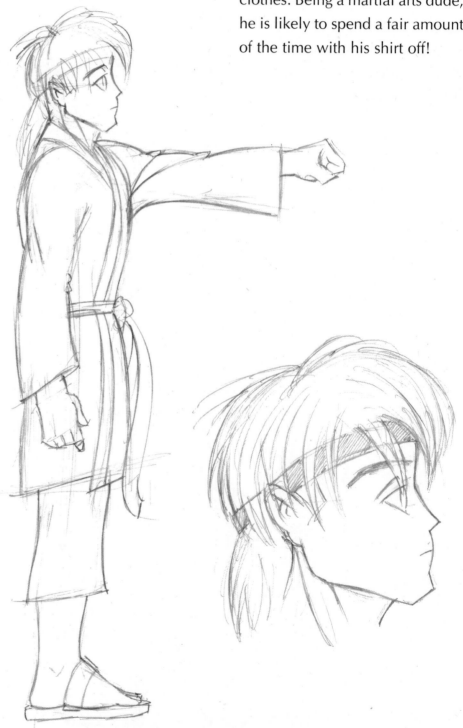

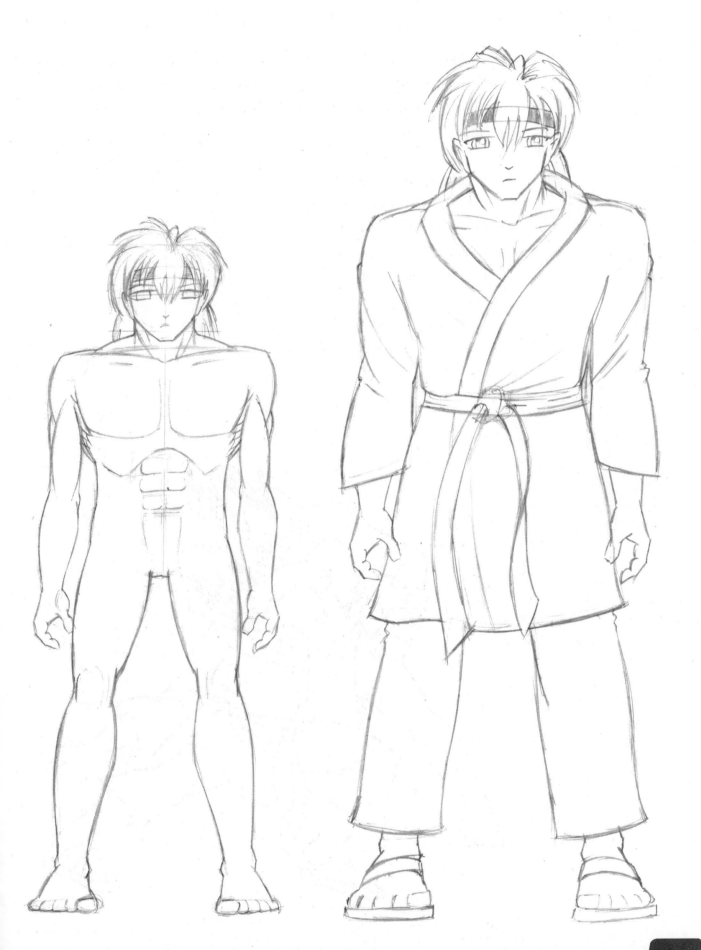

When a character is still in development it is a good idea to draw him/her in a few different scenarios.

It may sound strange at first, but we need to find out who these characters are. By this I mean how they behave in certain situations and what are their main motivations. Drawing some dramatic tableaus helps us come to decisions about their personalities.

The more we play around with our new-born characters, the more their personalities come through; via our own imaginations of course.

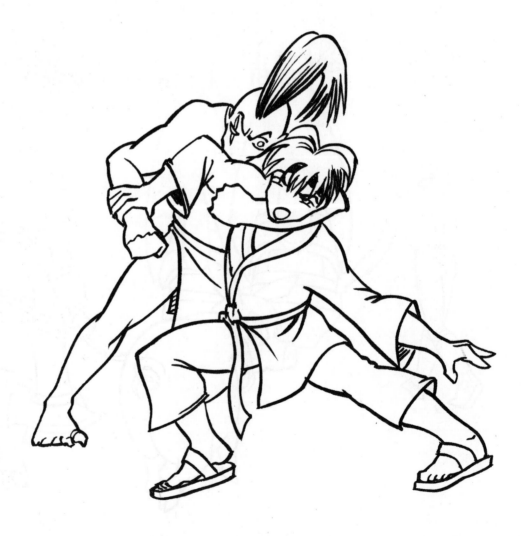

We can't leave this chapter without at least mentioning another stalwart of Manga – the giant mecha. Originally created as a line of toys, this concept has mushroomed over the years and has thousands of devotees worldwide.

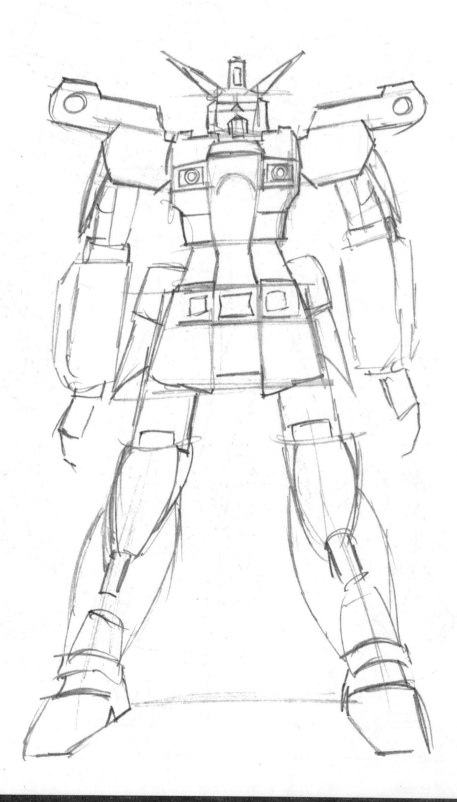

The principle point to remember when designing a collosal mecha is the sheer scale and power. How many heads high is the one on this page? Ten? Twelve? And this is a small one!

Mechas don't really have person-alities of their own as they are usually piloted by humans, often children. This forces all of the emphasis on to the pure design of the form. Power incarnate!

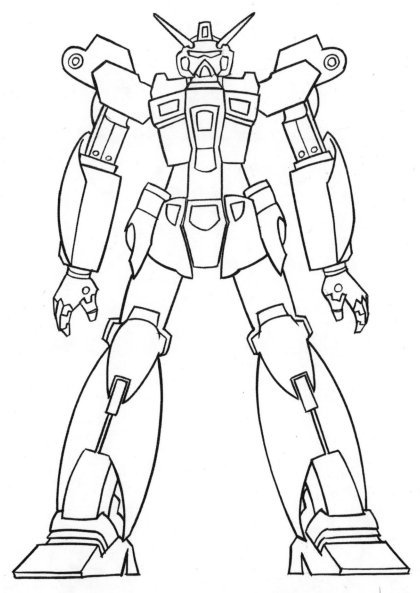

While being able to draw good characters is the most important part of creating your Manga world, without placing your characters in some kind of scene, you won't be able to tell much of a story.

Making believable scenery is a big challenge, but it's made a whole lot easier by understanding one quite straightforward technique – a technique known as perspective.

We all live in a three dimensional space, so it makes sense that our characters do too. What perspective allows us to do is make our Manga world seem 3D. Below is a simple representation of all you really need to know about basic perspective.

The two absolutely key things to understand are:

1: the position of the horizon line.
2: the position of the vanishing point.

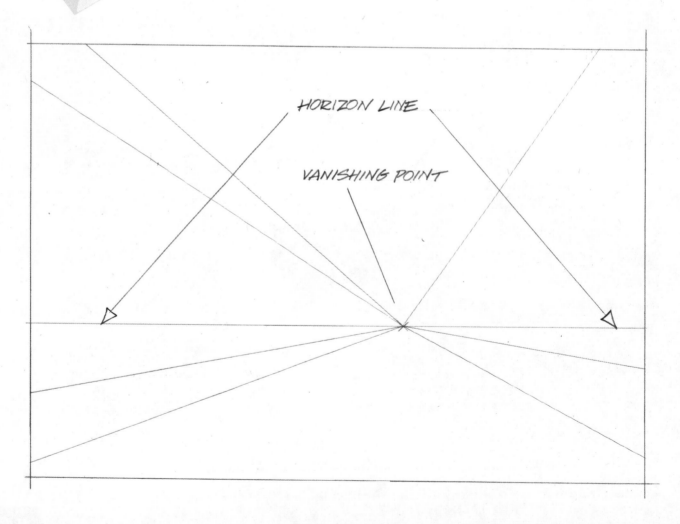

HORIZON LINE

VANISHING POINT

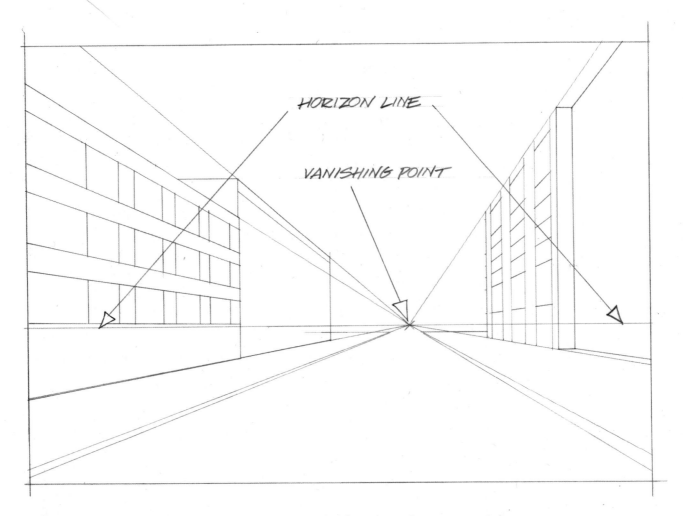

HORIZON LINE

VANISHING POINT

If we know these two positions it is easy to make a scene look realistic.

The picture above is exactly the same as on the previous page, only some buildings have been added. As you can see if you compare the two images, the lines moving toward the vanishing point have been used to form the basic shapes of our buildings.

In the second image we've started to use the same vanishing point to establish the windows in the buildings. Take note that every single line that isn't either a straight horizontal or a straight vertical moves toward the vanishing point. This could mean that we have hundreds of lines representing doors, roads, signs, etc, all leading toward this one dot on the horizon.

So what does this dot represent? As the name suggests, this is the furthest point we can see before the curve of the earth stops us seeing any further. It also relates directly to where we are positioned in relation to the horizon. The higher up we are, the further we can see and so the vanishing point moves back.

Still using the same vanishing point, we've now added more buildings, windows and the white lines in the road. The addition of the road lines are particularly useful as it puts something in the extreme foreground, helping to draw us in. Our scene is starting to look believable.

This technique is known as one-point perspective, for reasons you should now have grasped. There are other forms of perspective i.e. two-, three- and even four-point perspective which needless to say become more and more complicated when more points are involved.

One-point perspective is the most dramatic as it forces our focus toward one vanishing point. This has the effect of putting the reader right in the picture, and telling them immediately where they are standing.

This is the way we build up a

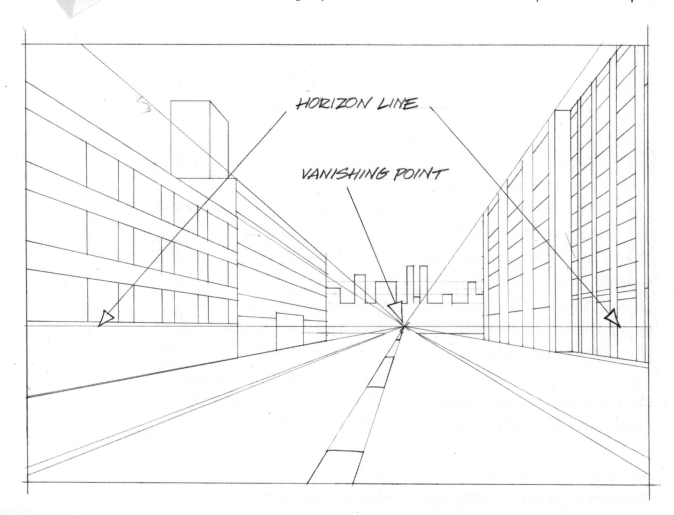

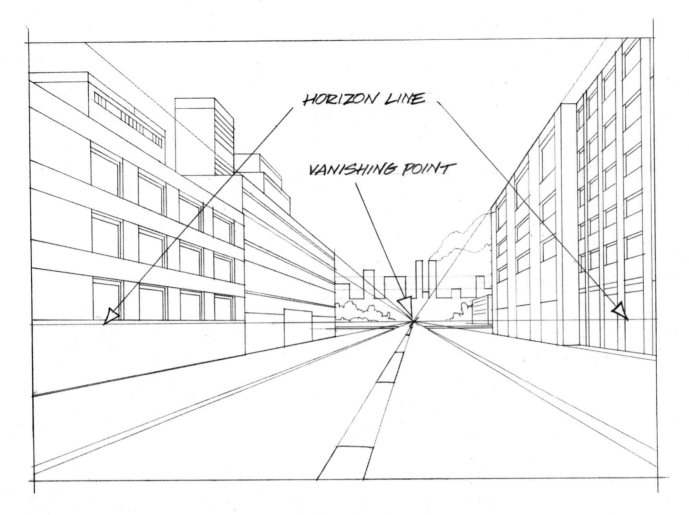

HORIZON LINE

VANISHING POINT

scene. The very first thing we should always do is establish where the horizon line is. The vanishing point is always on the horizon line. Where we place it depends entirely on the kind of scene we are drawing. It's a good idea though to avoid putting the horizon line exactly in the middle of the image as this usually makes for a pretty uninteresting picture. The same thing goes for the vanishing point – everything moving towards dead center rarely makes for high drama.

As the above image shows, we could just keep going and going,

using just this one vanishing point to build up a very complex and realistic scene. We could add cars using the same principle, but we'll wait until we've learned more about them on the next pages.

Without this simple technique, we'd just be guessing where the lines go. Taking the guesswork out is the best reason for taking some time to learn and practice perspective. If you look around you, you'll notice perspective. Being aware of these lines in reality will give you a better grasp of exactly how and why it works.

If we want to add some cars to our scene, we'd better understand how they're constructed. As always, we should begin with the most basic representation of the object.

The drawings on these two pages show the simplest way of seeing what a car really is: two boxes on top of each other and four cylinders underneath them. The smaller, top box can be moved backwards or forwards, depending on the type of vehicle we want to draw. This car is obviously a hatchback, but if we want to draw a sedan, we can just shorten the top box at the back.

The bottom box is around five times as long as it is tall and the wheel arches, represented by the two shapes at the bottom, come up to just above the box's half way line. The top box is around two thirds the height of the bottom one. If we stick closely to this formula, we should be able to draw believable vehicles.

Loosely speaking, we can stretch this shape if we want to make a sports car or squash it to make an economy car. We can mutate it to create something weird or futuristic as long as what's at the core of it is right.

When our template is done, we can start to add some basic shapes to get our drawing to look more like a car. We should be able to do this quite quickly, using only a few short lines.

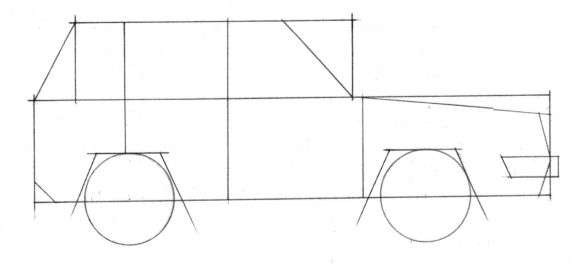

The picture above has had just nine lines and two circles added to it, but is now immediately recognizable for what it is.

These lines are then rounded or smoothed off to produce the image below.

We can then go on to add door handles, wipers, an antenna, etc, but this image shows that some basic understanding and a few carefully chosen lines are all we need to draw our own believable vehicles. Everything else is just detail.

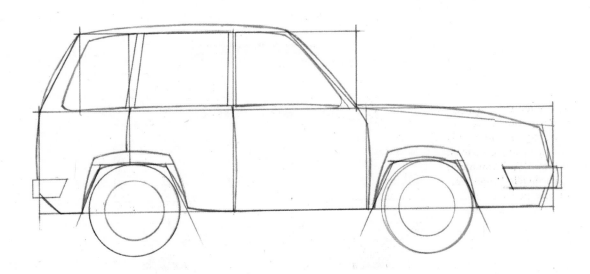

The front end of a car is possibly even simpler than the side view. Keep the height ratio the same for the two boxes, but make the top box a little narrower. This allows for the curvature at the side of the car, a tricky thing to work out if we don't yet know the structure well enough.

Opposite are some studies of one particular car. It's a very good idea to focus on and really get to learn everything we can about one car at a time.

When we realize that all cars are variations on a theme, we can make use of nearly everything we learn to help create our own vehicles. This goes for all inanimate objects.

The internet is a great source for images of cars. If you are really serious, you should even be able to download fully detailed blueprints of specific cars.

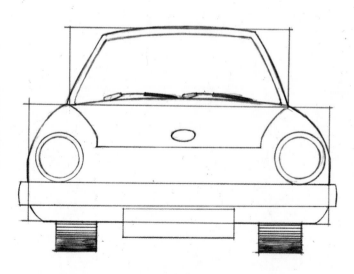

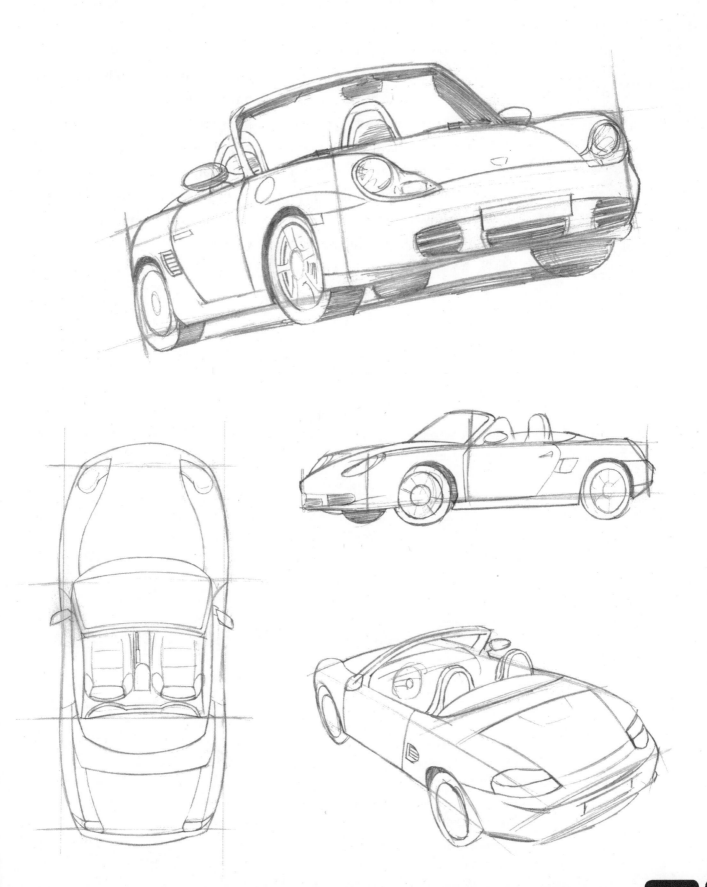

Remember we talked about other forms of perspective apart from one-point? In a moment we'll look at two-point perspective, but first we need to look at a problem we are likely to encounter a lot when drawing buildings. If we're drawing windows on a building which is disappearing into the distance, how do we know how to space these windows? We could simply guess, but fortunately we don't have to. If we draw two diagonal lines from the four corners that cross each other, this will automatically tell us the halfway point. We then just repeat this formula for as many divisions as we need!

Here's something a bit more challenging which introduces us to two-point perspective. What does two-point help us do? In this picture there are two vanishing points on the horizon, one for each side of the building. When we look at a building any other way than head-on, both sides get smaller, but move toward different points.

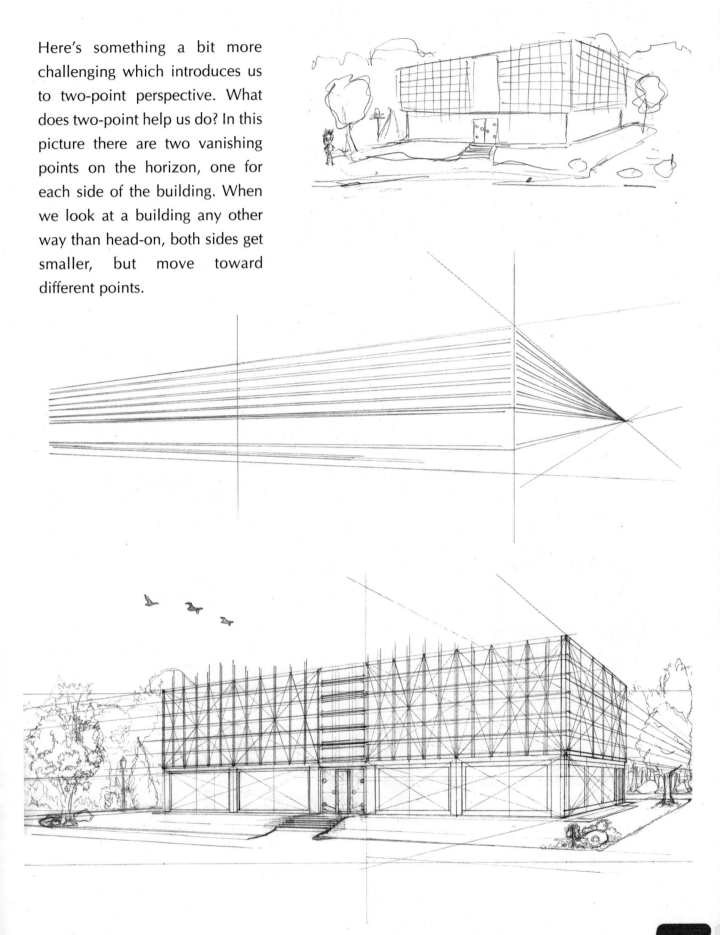

As you might imagine, something this big and complicated requires a little planning. A quick sketch helps us to establish the angles and to work out the incidental background detail. Because of the angle we've drawn this building at, the left-hand vanishing point will be so far left as to be off the paper. In cases like this, we can attach our paper to a board, giving ourselves a permanent point for marking off our perspective lines.

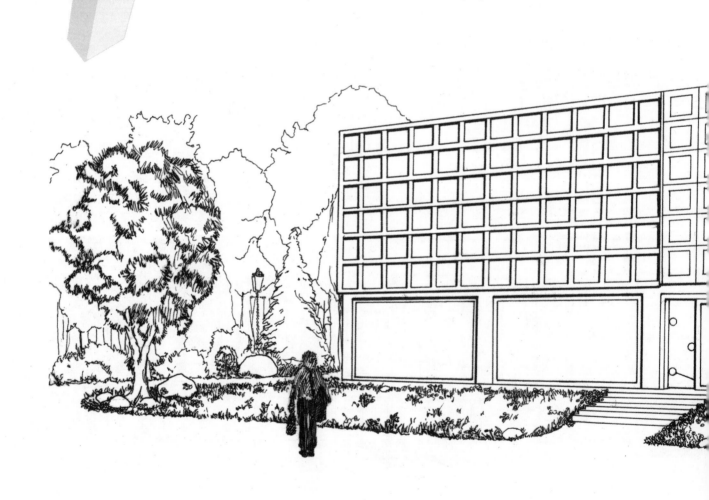

Once we've established all of the major perspective lines we can then work out where to put the windows. This is done using exactly the same formula we mentioned on page 116. Armed with just this basic geometry, we can now make our building look like a construction site!

This is an example of the kind of complexity we can acheive by knowing a simple formula. Try thinking of some of your own scenes to put these principles to the test.

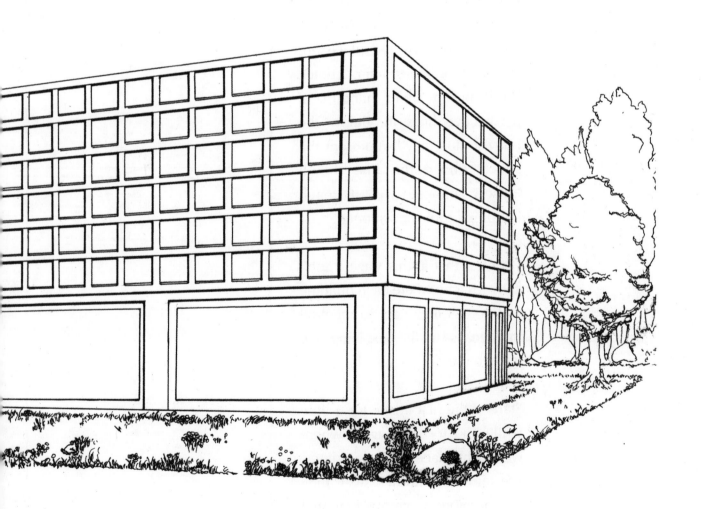

For this next section we're going to look at how to bring both cars and perspective together to make a scene involving a busy urban street. The shot will be at an intersection with the reader situated as if they were standing up in the car in the extreme foreground.

First things first. Let's put our horizon line in at about two-fifths of the way up. We'll use one-point perspective and place our vanishing point just left of center. We'll put a small handful of perspective lines in. Below the horizon line they'll represent the street. Above the line they'll loosely indicate where each building's roof is positioned.

I confess that at this stage I don't know exactly where each building will go. It's important to mention this because for the next image we have to use our imaginations.

Stare at the first image for a little while and try to imagine where we might place some buildings, We know the further away they are the more numerous they will be, so let's put a few lines in and see what happens.

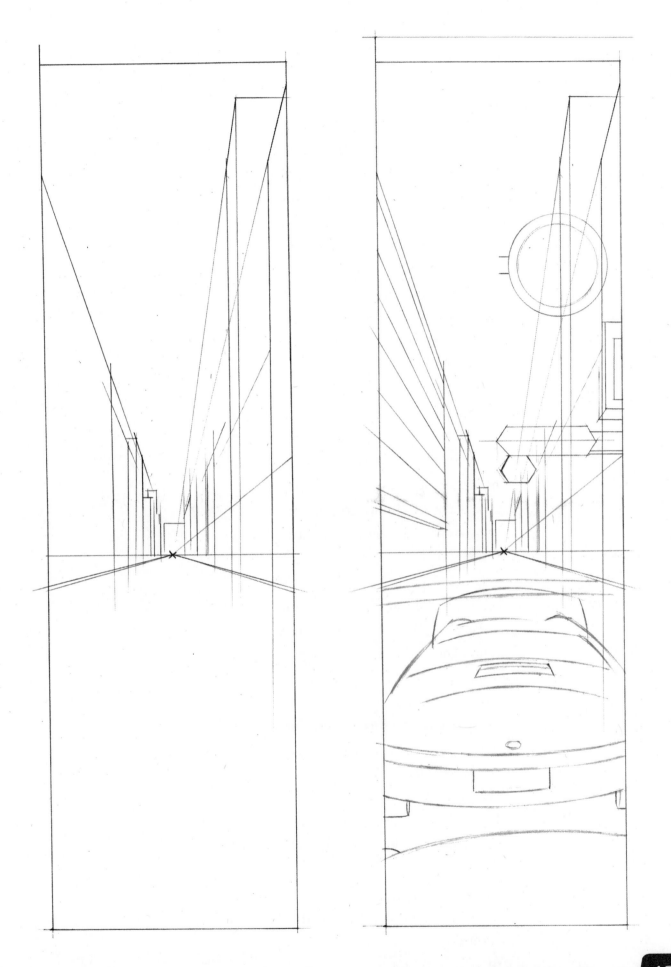

In the second drawing we can clearly see a scene beginning to take shape. But before we get carried away with the background let's work a little on the foreground. This means establishing where the vehicles waiting at the lights are going to be. We know they have to follow the same line as the street, so working out that part of the main car shouldn't be a problem. But as I mentioned earlier in the chapter, if our imaginations don't give us a clear enough image in our heads to work with, we simply go back to the two-box structure explained on page 112.

As the drawing shows an intersection, we need to draw traffic lights, stop signs, etc. We'll loosely indicate those for now.

Now let's concentrate on the background. A street should have streetlamps, so they need to be drawn in. Use the vanishing point to make the imaginary line formed by the fork at the top of the lamps. Let's create some traffic lights facing toward the left and work on the windows of the buildings.

Remember: big stuff first, little details last. It's all too easy to confuse an image like this if we're not disciplined about it!

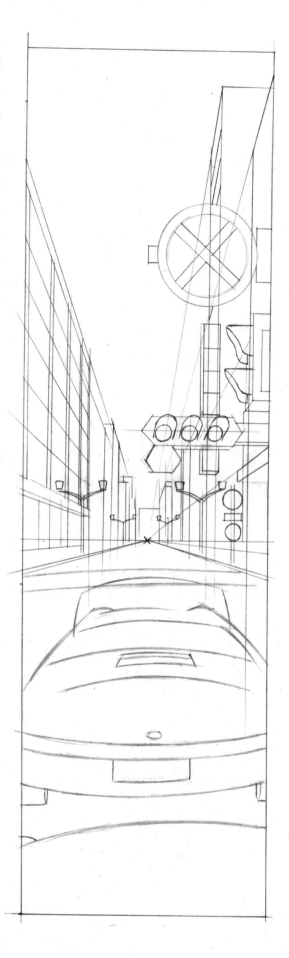

Now that the majority of the background detail is in place, let's finish working on the foreground. It's a good idea to work this way round as it keeps smudging to a minimum.

The cleaner we can keep our drawing the easier our job will be when it comes to inking. Lastly we'll finish the pedestrian crossing.

The only real blacks in this scene are kept for the foreground. As a rule, the further away an object is, the less black we should apply to it. This applies to the weight of line we use as well.

The heaviest lines have been reserved for the foreground, with very light strokes representing the buildings right at the back of the scene.

By creating the effect of distance in our scene, we can ensure the reader will immediately understand the image without having to spend even a second trying to work it out. In storytelling this instant grasp by the reader is essential for a smooth flow.

We're nearly ready to ink. We've saved the smallest detail until last. Let's populate the street a little with some shoppers. We shouldn't waste time trying to inject much character or detail into these extras. They are there for scene dressing, not for distracting us!

Try not to draw incidental characters like these too evenly spaced. Break them up and have them facing different ways.

We'll throw in a couple of parked cars down the street and tighten up any lines that need re-strengthening.

It's time to get the ink bottle out.

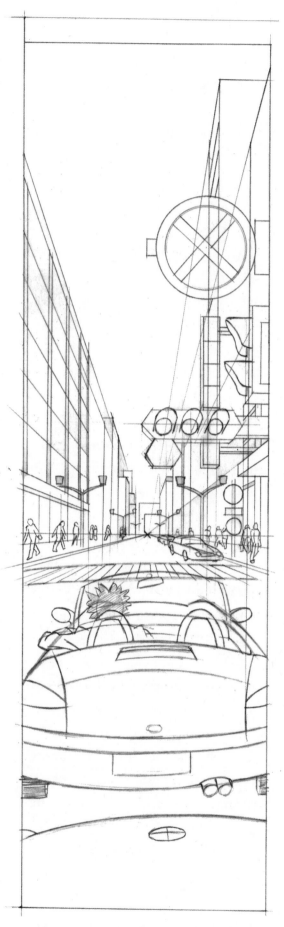

If we use a brush or dip pen and not a marker or other kind of quick drying pen, there's one problem that always faces us when doing a large inking job. Before long we are looking at a sheet of paper with wet, easily smudgable ink on it. We know from experience that working anywhere near these areas invites disaster, but we need to get on.

The answer? Where possible, work in batches. It's a good idea to put a few images for inking to one side for finishing later. We can then work in a production line style, rotating them as we add ink.

This image was done using a combination of dip pen for the architecture and brushwork for the curvier lines. This tends to have the effect of separating the hard lines of the buildings from the more organic forms of the people and cars.

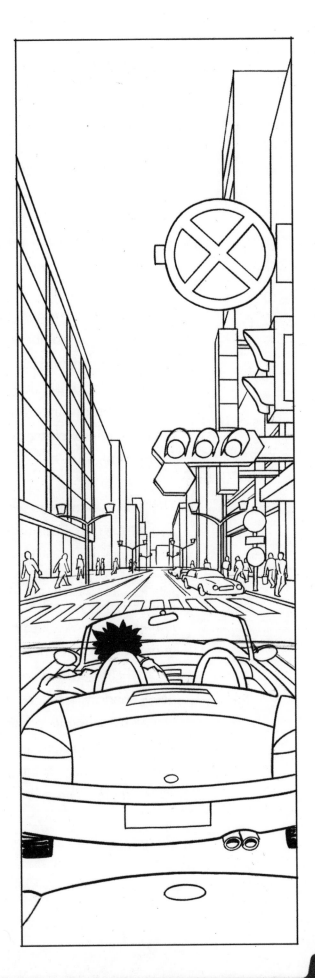

Once the ink is dry and the image has been scanned, we can start to think about toning up. This can be done with any graphics program. The aspect we need to consider most is the balance of the tones.

As we mentioned in the previous page, objects become lighter as they get further away, so we know not to use any very dark tones in the distance. We'll save anything approaching pure black for the foreground.

That leaves a lot of grays to think about. We'll assume the sunlight is coming more or less directly from above, so the sidewalks and pedestrian crossing should remain white. We know that the underside of the hoods of the traffic lights are going to be in deep shadow. This is how we begin; by working on the tones we have little or no choice about. The rest is just a question of achieving balance and depth.

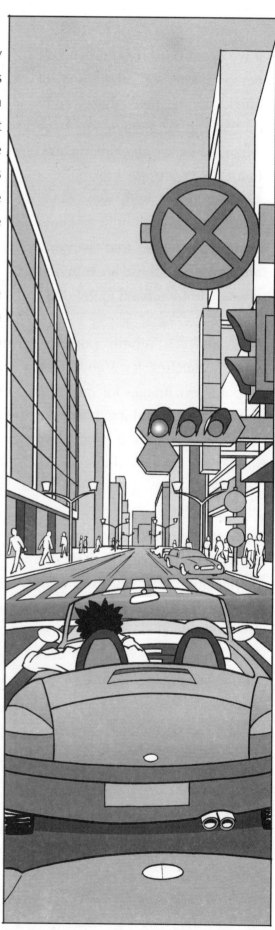

When we've toned everything, the next step is to make the art print-ready. This means converting all those gray tones into tiny dots of black.

Printing presses don't print in gray. They print only in black on white. So how does Manga achieve such a wide range of gray tones? The picture to our right should give us an idea. What looks like gray on the Manga page is actually hundreds if not thousands of tiny black dots, arranged so as to be indistinguishable from gray. In some Manga the dots are big enough to see without squinting and is part of what has given Manga its distinctive look.

Traditionally these effects were produced with tone sheets – transparent, adhesive-backed sheets with these tiny dot patterns on them. These were laid on top of the inked artwork. The artist could then paint white highlights straight on to the tone sheet.

At right is a digital version of a variety of gauges of tone. At the top of the image the tone is very fine and almost indistinguishable from gray. At the bottom, the dot pattern becomes obvious.

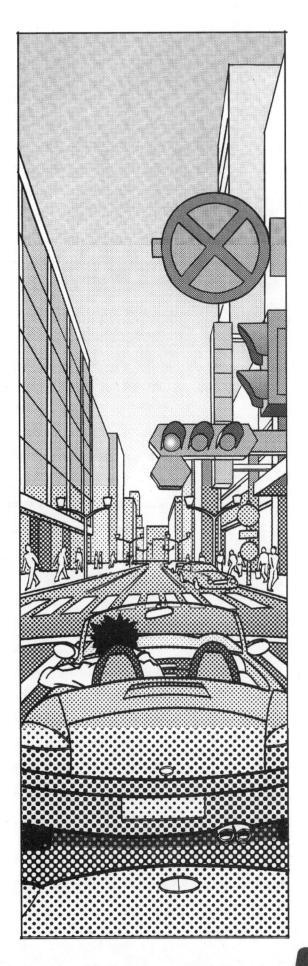

So, how do we apply these tones using a computer? First we need to select some or all of the tone using the magic wand. We then copy and paste this into a new document. Next, we have to change the mode of the image from grayscale to bitmap. This is the most important part. When we change modes to bitmap, we are creating what's called a halftone screen. This is exactly what we were talking about on the previous page. This effectively reduces everything in the image to either black or white. In simple terms, this means either "on" or "off", i.e. one computer bit's worth of information.

We have a choice of shapes to use for our halftone screen; diamonds, lines, etc. but the appropriate one for Manga is simply round. We can also specify the size of dot we need. You'll need to experiment with this as it is dependent on the size of your image.

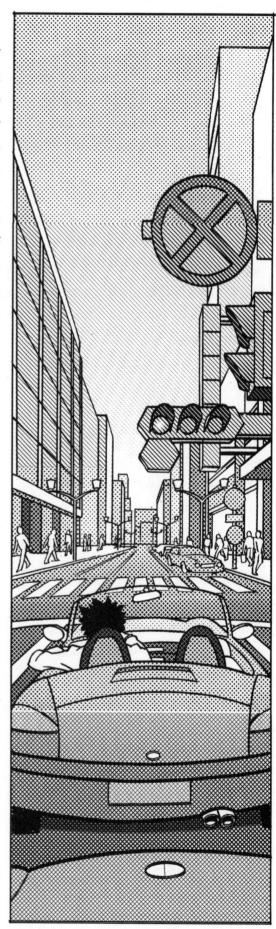

When we've finished bitmapping, we'll need to convert the tone back to grayscale before we can copy and paste it back into our original image. Use the image/mode selector in the menu to do this.

The subject of inking and toning for Manga is worthy of an entire book in itself, rather than the scant few pages we have to discuss the topic.

Experimentation is again the key to making your own discoveries. If you see an effect by a favorite Manga artist and don't know how it was done, make it a mission to find out! Even if you don't get the answer you were looking for you're bound to turn up some good ideas on the way.

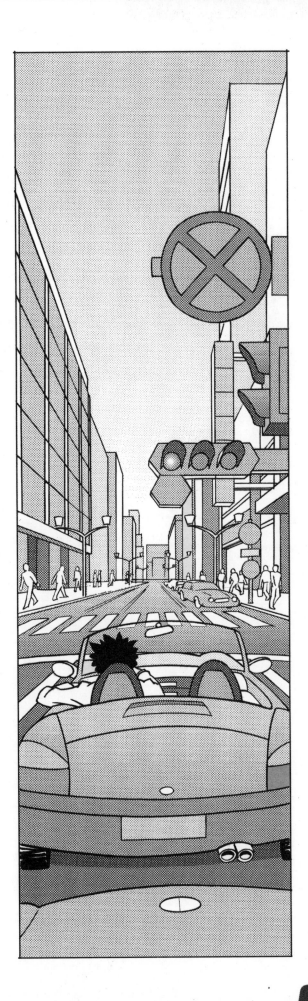

Perspective which is precise in technical terms is all very well and will probably serve us fine in many situations. But anyone who lives outside of a modern, well-planned city will tell you real life just ain't like that! Examine the image on the right. All the previously discussed rules of perspective are there. It's just they seem to have been bent out of shape. What do we do when the building we want to draw has a curved wall? What if the road is bumpy and built on a series of small hills?

Not to worry. We just have to modify the rules. The horizon line hasn't gone anywhere, it's just harder to work out, that's all.

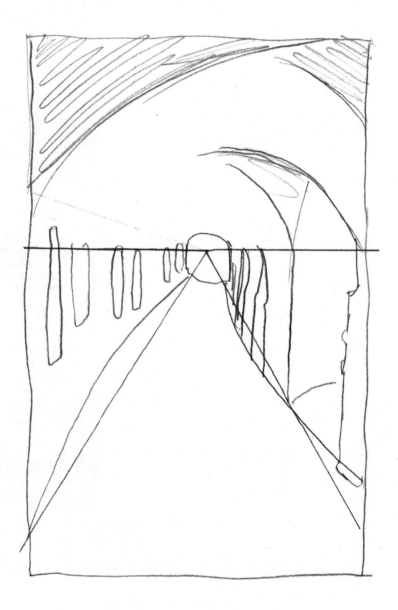

Drawing real life scenes like the ones on these pages can teach us a lot. Real life is far more random and unpredictable than geometry. In the olden days, people would build what they could where they could. But as mentioned before, the rules are still there, it's just a question of being able to see them. The sketch versions of the images on these pages represent just that; an attempt to work out the horizon line and any obvious vanishing points. If our ultimate aim is to make our Manga convincing, we have to inject at least a little of the unpredictable into our artwork. It's this unexpected element that makes all the difference.

No action scene is complete without sound. Sound effects in original Japanese Manga are of course in Japanese.

Western translations have developed their own style quite distinct from mainstream comics.

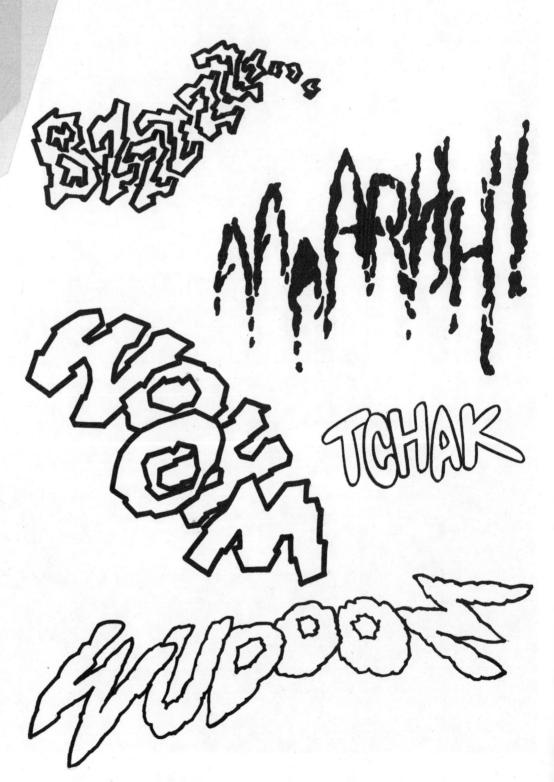

Good sound effects have to be properly thought out and designed. The key elements are expression and legibility. As these two factors can potentially be in conflict a good balance and compromise needs to be arrived at. These examples show how sound effects are constructed.

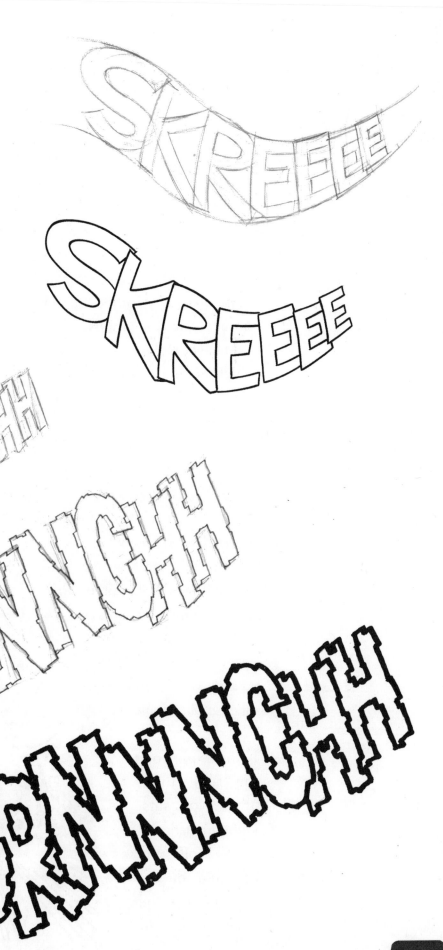

There's nothing quite like a good meaty explosion to add life to a Manga page. Smoke, explosions and other pyrotechnics can be harder to do properly than we might think.

All of the above have structure, just like any other objects. Smoke and clouds have distinctive patterns of behavior which need to be studied if our Booms are to have any real impact.

A big contributor to the energy of an explosion are speed lines. These are a real staple of Manga. It's hard to find many stories that don't feature them heavily. They are used to add life not just to moving things but also to add drama to characters, add focus to a scene and many other applications.

In the explosion to the right there are two sets. One dramatically shows off the direction of the impact, while the other helps to

show the immense outward force of the blast.

The facing page shows the kind of energy we can achieve when we combine our speed lines and explosion with some onomatopoeia. By onomatopoeia we mean `WUDOOM', or any other non-word noise. Master all three of these for a truly powerful package of techniques.

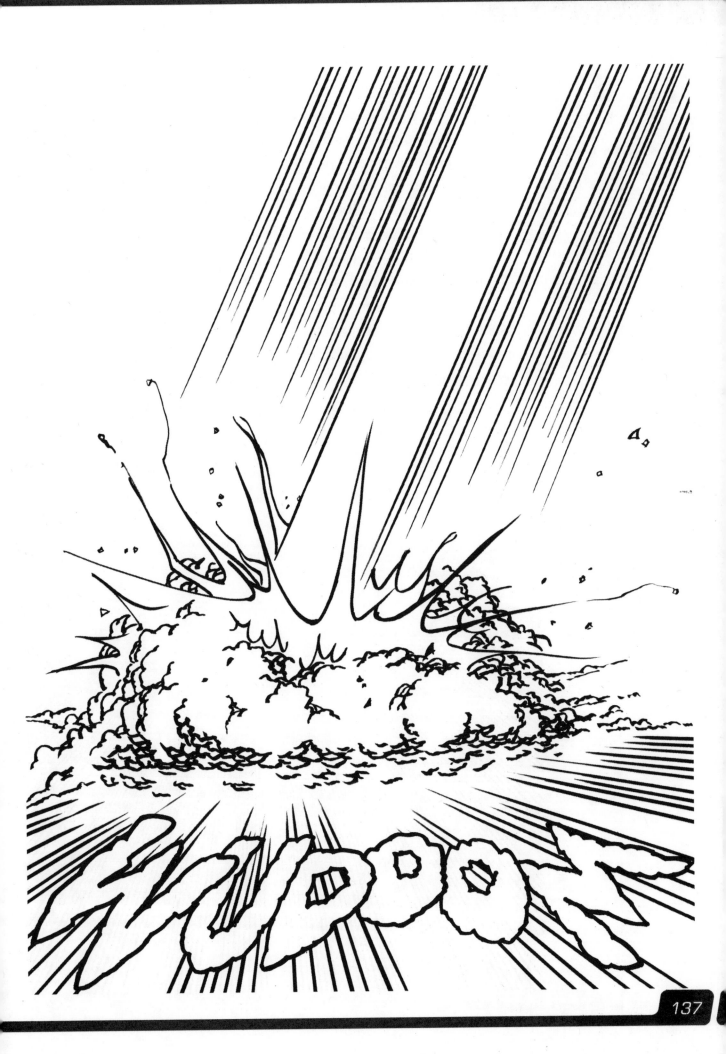

If you need any further convincing of the power of speed lines, these two pages should help. Often in Manga there is nothing for an entire page except for characters and speed lines. They can serve as temporary replacements for backgrounds or even take the place of perspective.

Good speed lines take a surprising amount of practice to perfect. Here are some pointers:

– Don't make your lines too even. Try to vary the width of the line.

– Where the line tapers to nothing, try to avoid them ending at the same point.

– Plan exactly what you want to achieve before starting!

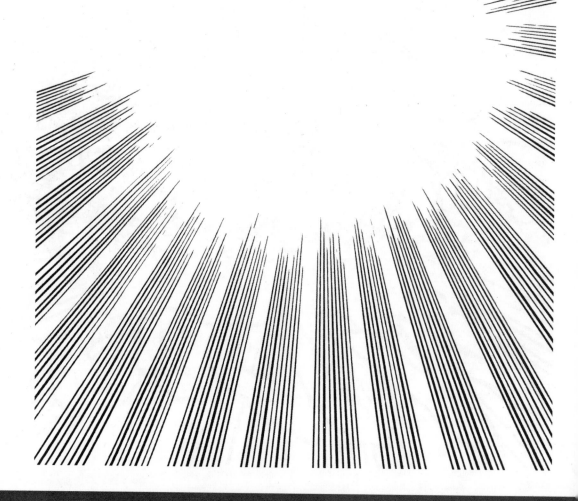

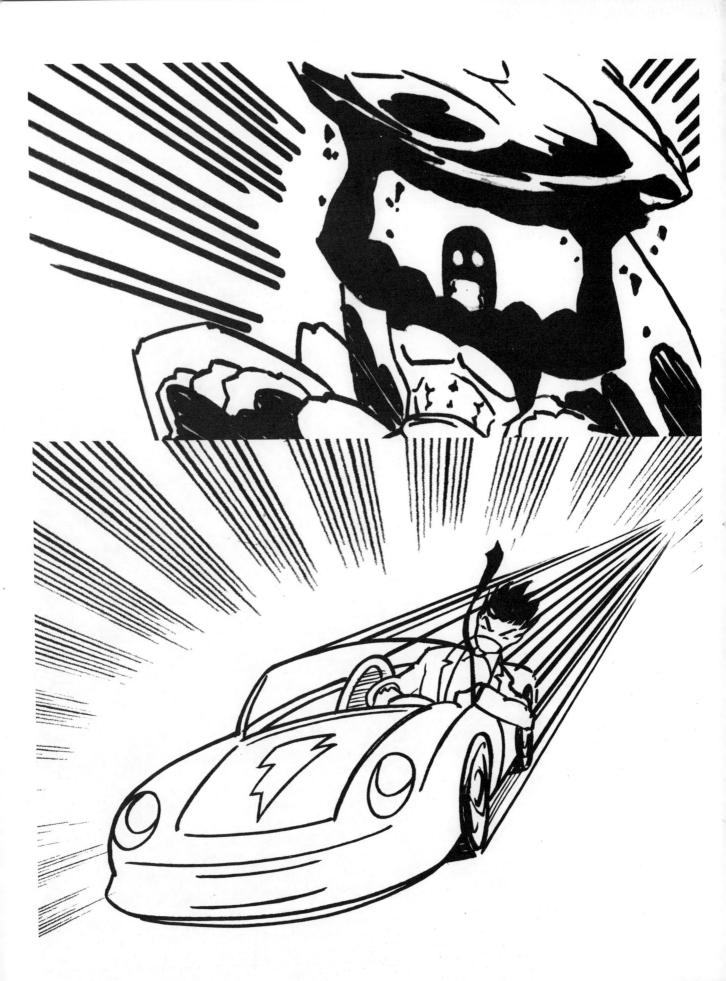

These are traditional Japanese patterns. They have been around in the Far East in some cases for centuries. Their precise geometric shapes can help us achieve an element of Japanicity in our Manga. Have a look at the front cover of this book: you'll see that

the floor on which our characters are standing is constructed from just such a pattern.

A lot of Manga uses quite abstract patterns for background when a particular mood is needed or when more of a design element is required.

Get out there and sketch! Seriously, there's nothing like real life to constantly surprise us with new ideas and force us to see things we haven't noticed before.

It can be perfectly satisfying to only create art from our imaginations, but if we take a good look around at the world we live in, our artistic lives and our Manga will be the richer for it.